# DUMFRIES
## THROUGH TIME
Mary Smith & Allan Devlin

AMBERLEY

First published 2015

Amberley Publishing
The Hill, Stroud, Gloucestershire, GL5 4EP
www.amberley-books.com

Copyright © Mary Smith & Allan Devlin, 2015

The right of Mary Smith & Allan Devlin to be identified as
the Author of this work has been asserted in accordance
with the Copyrights, Designs and Patents Act 1988.

ISBN  978 1 4456 3767 9 (print)
ISBN  978 1 4456 3779 2 (ebook)

British Library Cataloguing in Publication Data.
A catalogue record for this book is available from the
British Library.

Typesetting by Amberley Publishing.
Printed in Great Britain.

# Acknowledgements

We are grateful to everyone who helped us gather material for *Dumfries Through Time* and who provided images, information, memories and anecdotes. Their generosity has been humbling and if we included everything we were offered, the book would have been several times the length it is. Both the archive centre at the Ewart Library and the Museum hold excellent collections of images of old Dumfries and our thanks go to Alison Burgess, Local Studies and Information Officer at the Ewart Library and Joanne Turner, Museums Officer, Dumfries Museum and Camera Obscura for all their help. The Old Dumfries Facebook page has many old photographs of Dumfries and a group of enthusiastic followers who love nothing more than to share images and answer queries.

We are grateful to Sandy Pittendreigh from the Family History Society for sharing his knowledge and advice. Thanks go to people who provided images from their private collections including Morag Williams (who could also be relied upon to answer sudden questions emailed to her in a panic). A huge thank you goes to John Kerr of Dumfries who so generously allowed us to borrow from his extensive collection of old postcards. Without John this book would not have happened. We are indebted to Jon Gibbs-Smith for IT support and to Lynn Watt – without whose eagle eye this book would have a lot more commas than it does.

Credits for images from the Dumfries Museum and Camera Obscura Pic: 3, 8, 9, 10, 13, 23, 24, 30, 31, 69, 86, 87

# Introduction

Situated on the River Nith in south-west Scotland and known, like its well-supported football team, as Queen of the South, Dumfries was granted royal burgh status by David I in 1186 and is the administrative capital of the Dumfries and Galloway region. People born in the town proudly refer to themselves as Doonhamers.

A few hundred yards downstream was the royal castle of Castledykes, guarding the route from England. Depending on changing fortunes throughout several centuries the castle was occupied by Scottish, English and Norman troops. The town was raided and burned several times during those years of border warfare.

In 1262 Lady Devorgilla, the mother of King John Balliol, gave land to Franciscans to build a monastery at the top end of what became known as Friars Vennel. It was here, in front of the high altar, the face of Scottish history was changed in 1306 when Robert Bruce and his follower, Sir Roger de Kirkpatrick, stabbed to death the Red Comyn, a rival claimant to the Scottish throne.

The 1870s and 1880s brought Dumfries a period of economic prosperity thanks to Queen Victoria and her family making Scottish textiles fashionable. This led to growth in the town's tweed industry, making it one of the largest tweed producers in the world. Almost 2,000 workers were employed whose wages raised the standard of living in the town. It was around this time public buildings still seen today were erected.

Dumfries was always an important market town for south-west Scotland. The weekly market on the Whitesands dates from 1659 with 20,000 head of cattle being sold annually. The introduction of the railways and a weekly auction market reduced this greatly with fewer than 10,000 cattle being shown in 1865. Tanning, shoe-making and clog-making, and saddlery were once important industries in Dumfries. In the early part of the twentieth century Arrol-Johnston established a car factory but it closed in 1931, partly through an unwillingness to adopt mass production practices.

Four bridges span the Nith including one of the oldest standing bridges in Scotland; Devorgilla Bridge, named after Lady Devorgilla, who reputedly built the first wooden bridge at the site. She also founded Sweetheart Abbey, in the nearby village of New Abbey.

The once-thriving port included Dumfries, Kingholm Quay, Kelton, Glencaple and Carsethorn. By the eighteenth century the town had established links with the colonies in America, importing tobacco. Other imports included coal, brandy, wines and luxury textiles from Spain and France, all of which encouraged the smuggling trade. Serious decline began with the coming of the railway, coupled with increasing costs of improving the channel.

Scotland's bard, Robert Burns, spent his final years in Dumfries and, understandably, many places in the town have connections to the poet: from the house where he lived to his mausoleum in St Michael's churchyard. One of his favourite drinking places was the Globe Inn where the Burns Howff Club meets today. In the bedroom where Burns stayed can be seen the lines of poems he scratched in the windowpane and visitors can sit in the chair he favoured – though custom dictates whoever sits in it must recite a Burns' poem.

The town also boasted being home to the Crichton Royal Hospital – one of the country's leading mental hospitals. It was founded in 1839 after James Crichton left £100,000 in his will to be used for a charitable cause. His widow, Elizabeth Crichton, wanted to build a university but was thwarted by the existing educational institutions. Today it is home to the Crichton Development Company and the Crichton University Campus, a multi-institution campus which includes Glasgow University, University of the West of Scotland, The Open University, Crichton Carbon Centre, Dumfries & Galloway College and the Scottish Agricultural College – so Elizabeth Crichton had her wish at last.

Doonhamers still enjoy their festivals such as Guid Nychburris, which includes the Riding of the Marches and crowning the Queen of the South. Thanks to the Guild of Players who purchased the building before it could be demolished, the town still has the oldest working theatre in the country, the Theatre Royal.

The photographs show that much has changed in Dumfries – not always for the better. The demolition of historic buildings, especially in the heart of the town, is sad. The High Street, once filled with family-owned shops, now has the homogenised appearance of many other towns. It is to be hoped town planners are beginning to understand the importance of the town's built heritage before more is lost.

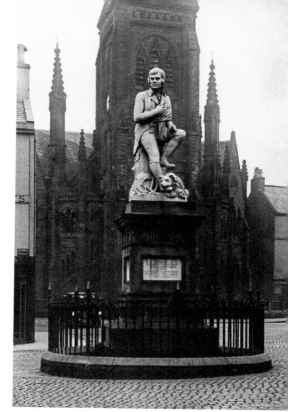

**Burns Statue**

Unveiled by the Earl of Roseberry in 1882, the model for the statue of Scotland's bard, Robert Burns, was by the artist Amelia Paton Hill who had exhibited at the Royal Academy. The statue was carved in Carrara by Italian craftsmen and shows the poet sitting on a tree stump, his dog at his feet. Over the years it has been moved several times due to road improvements and some new landscaping has recently been completed.

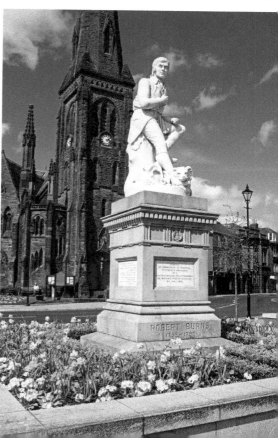

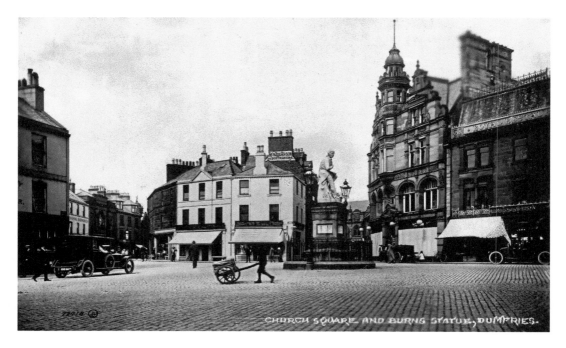

CHURCH SQUARE AND BURNS STATUE, DUMFRIES.

## Church Square

Despite the demolition of several premises, the area retains much of its character, thanks to the architecture of the buildings. Greyfriars Church, out of shot in the nineteenth-century image, is hidden by the shops and houses no longer there. The today photograph shows the new layout around Burns Statue.

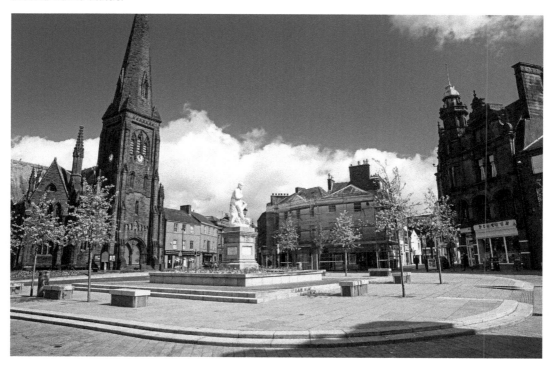

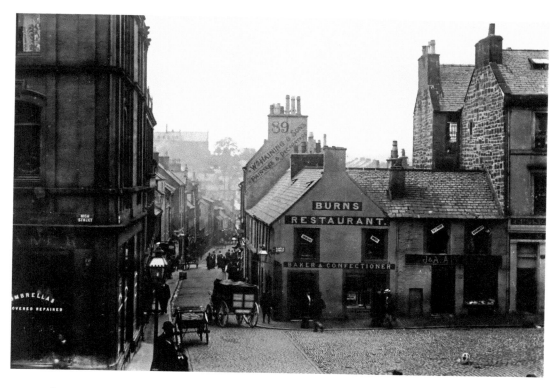

## Friars Vennel (from the top looking down)

Looking down the narrow cobbled street of the Vennel from High Street it is hard to imagine this – centuries earlier than this nineteenth-century photograph – was once the main thoroughfare for pilgrims to Whithorn, immigrants from Ireland and invading armies during the English Wars.

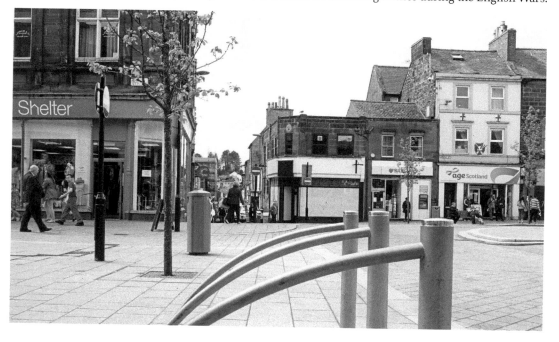

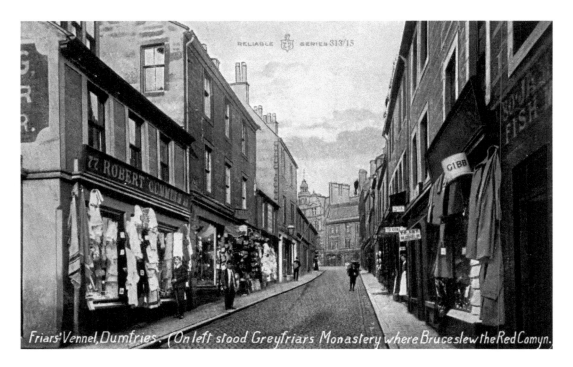

Friars' Vennel, Dumfries. (On left stood Greyfriars Monastery where Bruce slew the Red Comyn.

**Friars Vennel (from the mid-way, looking up)**

In existence since the tenth century, Friars Vennel is one of the oldest and most significant streets in the town. In the late thirteenth century Devorgilla founded Greyfriars Monastery, on the left at the top of the Vennel (hence the Friars), in memory of her husband, John Balliol, who died in 1269. And it was in front of the high altar there that Bruce killed the Red Comyn in 1306, changing the course of history.

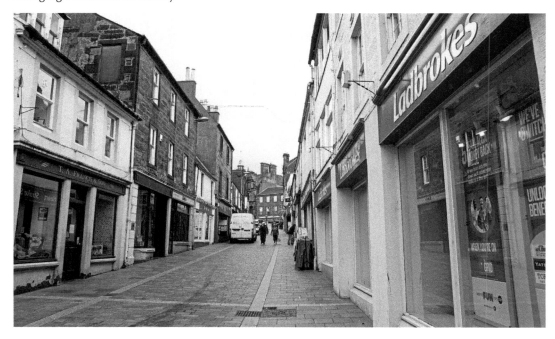

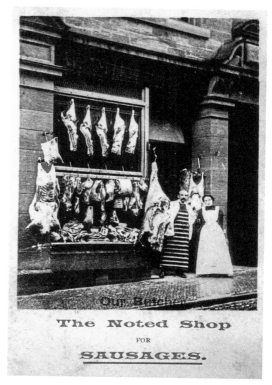

**W. Milligan Butcher, 45 Friars Vennel**
Noted for its sausages according to this
advertising postcard, the butcher shop at
the beginning of the 1900s also had beef
and mutton of the best quality, and
lamb and veal in season. It was situated
on the Vennel, just below where Mogerley's
butcher shop is now.

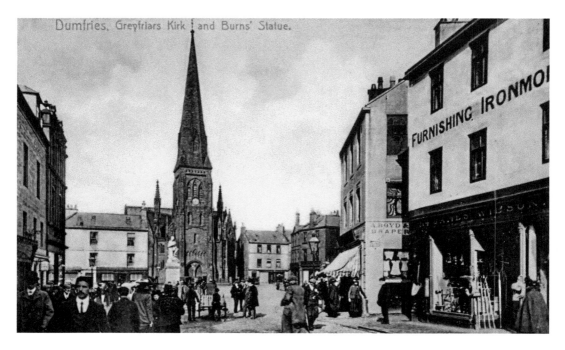

## Greyfriars Kirk and Burns Statue

A busy scene in this early photograph taken at the bottom of High Street – busier, indeed than in the modern picture. The light coloured buildings to the left of Greyfriars were demolished in 1937. Ironically, in view of the betting shop on the right in the modern photograph, gambling stalls were removed from the area near the church.

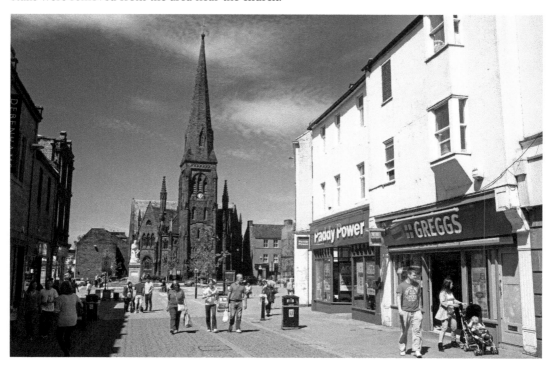

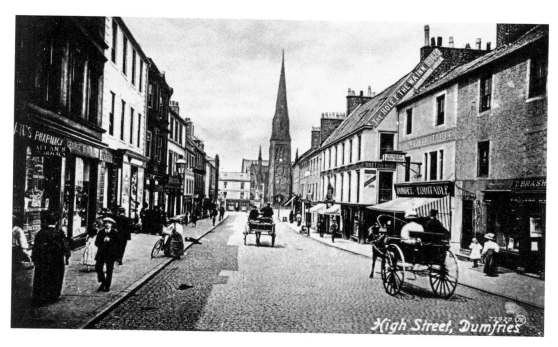

## High Street

Looking from the Midsteeple down High Street towards Greyfriars Church. With horse and trap appearing to be the preferred mode of transport, the woman on the left of the picture with her bicycle must have been quite an unusual sight. Riding it while wearing the fashion of the day must have presented some difficulties. On the right of the photograph, The Hole I' The Wa' Inn makes sure it is noticed with its sign on the roof.

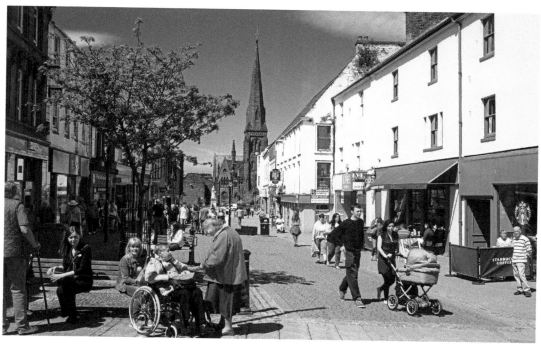

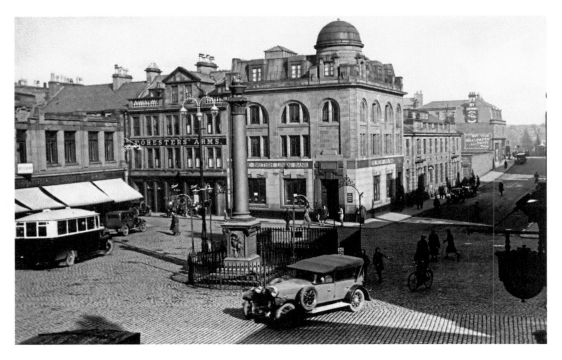

## Queensberry Square and Monument

The Square was once more enclosed than now but the eastern part was knocked down to make way for Great King Street. In the mid-1930s the public lavatories, behind the monument to Charles, the 3rd Duke of Queensberry from Drumlanrig Castle, were removed as well as the monument to make way for traffic. The monument sat outside the council buildings before being returned to its rightful place and the square is again traffic free in 2015.

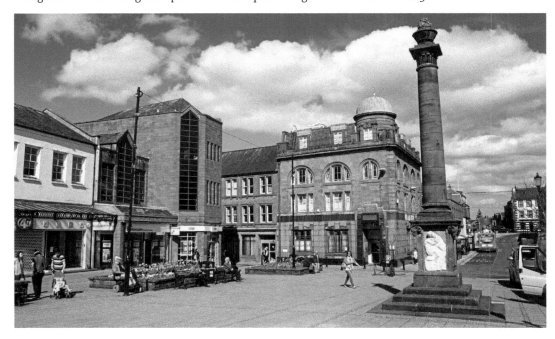

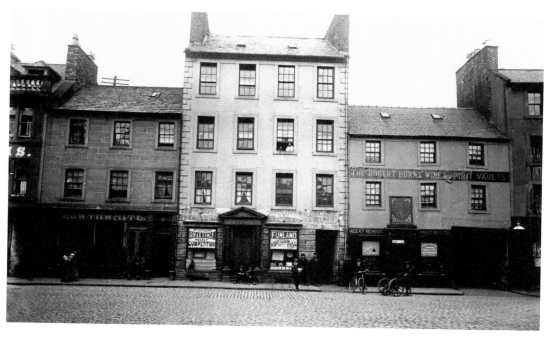

## Queensberry Square

This 1915 view of the eastern side of the square shows the entries to some of the old Dumfries closes. Below The Robert Burns Wine and Spirit Vaults is Wide Entry Close, three men stand at the entrance to the Lion and Lamb Close and further to the left is the Beehive Close. Great King Street in the new photograph was created when the closes were demolished.

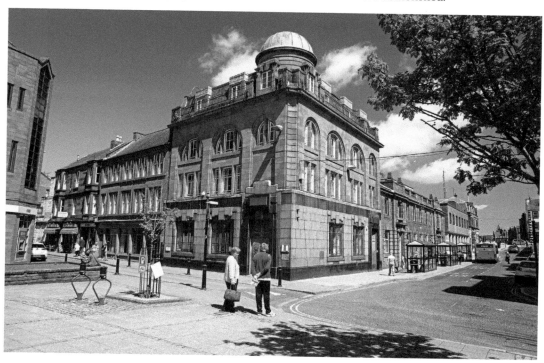

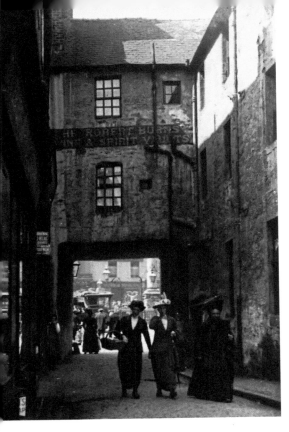

### Wide Entry Close

Three women, giving us a fascinating glimpse of the fashion of the day, including the lady on the right who seems to be dressed in mourning clothes, walk from what appears to be a bustling Queensberry Square through the close. The demolition of the closes meant the loss of homes and people in the town centre.

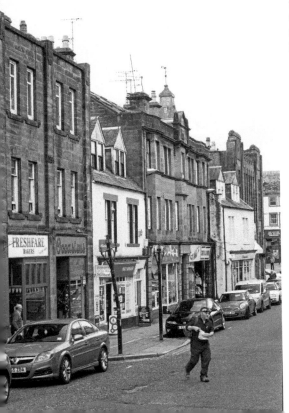

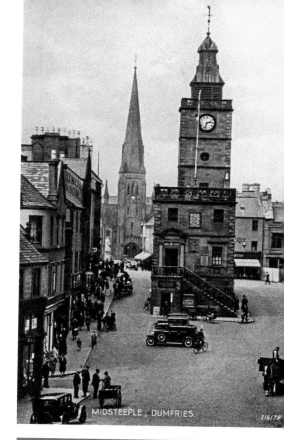

MIDSTEEPLE, DUMFRIES

**Midsteeple, High Street**

Perhaps the town's most iconic landmark, built 1704–08, it still dominates the High Street. The ground and first floors originally contained the weigh-house, town-guard house, and town hall. Stone plaques depict the royal arms of Scotland and Dumfries's patron saint, St Michael. The ground floor is now a box office selling tickets for events in and around the town. In the 1970s it underwent extensive strengthening as well as major restoration in 2007–09.

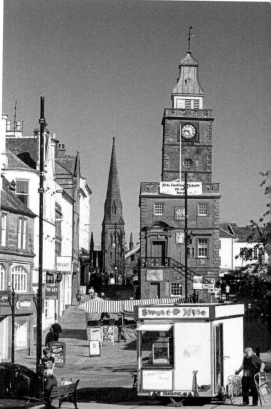

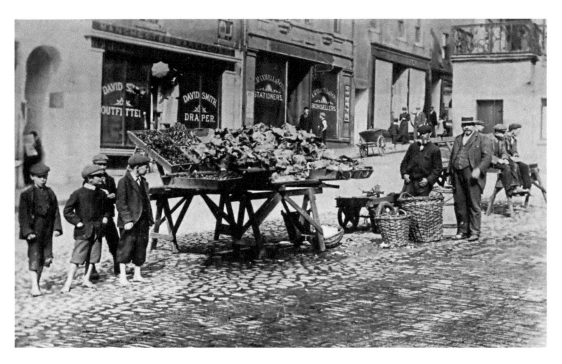

The Gardeners' Stalls, Plainstanes, Midsteeple

By 1910 the once thriving vegetable market in front of the Midsteeple had been much reduced from earlier years. The boater-hatted 'Chaiwe' Kennedy stands by his stall watched by a group of lads, all barefoot. In the background can be seen some of the range of family-owned shops – now a thing of the past in the town centre, although there is still a weekly market.

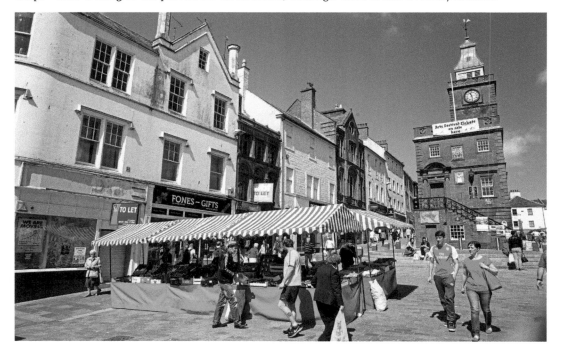

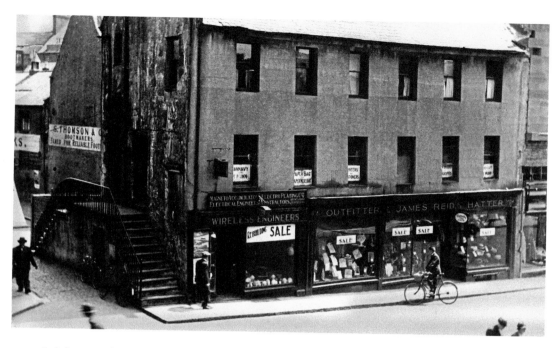

### Rainbow Stairs, Old Union Street

A tollbooth built in 1481 was rebuilt around 1718 as a council chamber with shops below. Entry was at the top of the stairs and it was used for council meetings until 1832. Under the Rainbow Stairs was a small lock-up for prisoners, which was in use until the Midsteeple was built in 1707. Proclamations were made from the top of the stairs and thieves branded with the town clock key. The council chamber became the Rainbow Tavern. Burton's development led to the demolition of this historic part of town.

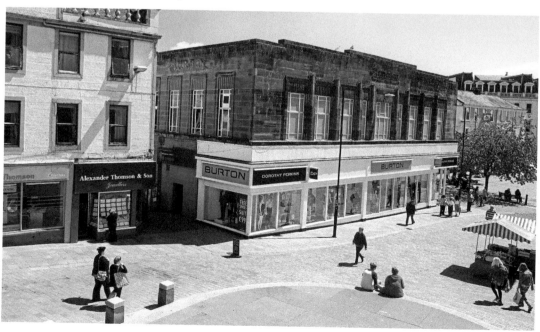

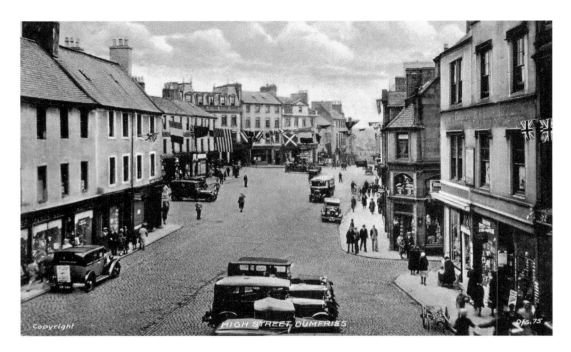

High Street

Looking along the street towards the fountain, many cars and even a bus can be seen in what is now a pedestrianised area. Shoppers are out and about in what was the busiest street in the town with its wide range of independent shops. Flags strung across the street indicate a time of celebration in the town, possibly *Guid Nychburris*.

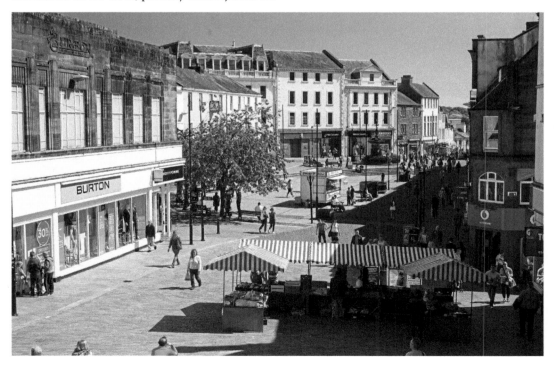

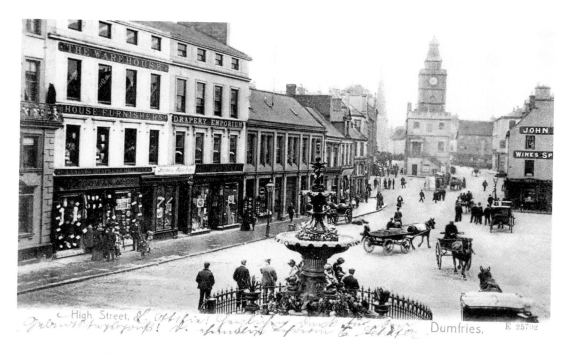

High Street, Dumfries. E 25702

## Fountain, High Street

The present day fountain was erected in 1887, replacing a previous one erected in 1851 to celebrate the piping of fresh water into Dumfries. The three-tiered iron construction is lavishly decorated with dolphins, a stork and four cherubs squeezing, in a most un-cherubic manner, four crocodiles to produce the water. Now, as always, it's a popular place from which to watch the world go by.

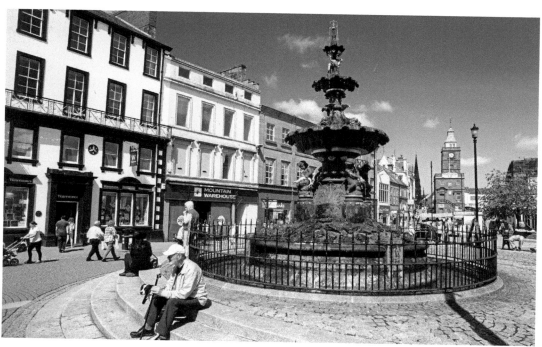

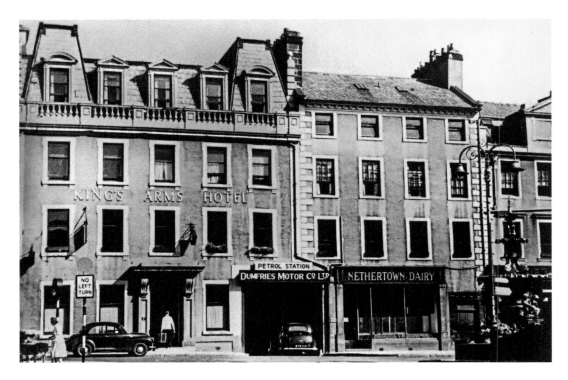

King's Arms Hotel, High Street

A listed building and an important part of the town's history since the eighteenth century. As well as the mail coach for Stranraer, daily passenger coaches went to Castle Douglas and Kirkcudbright. It was demolished in 1973, although the original frontage was kept – as was the ghost of a young widow supposedly felt by a worker in Boots the Chemist, which now occupies the site.

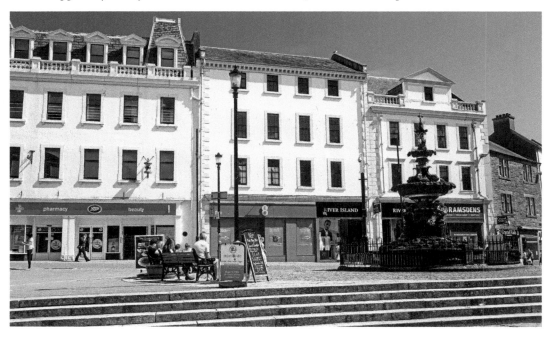

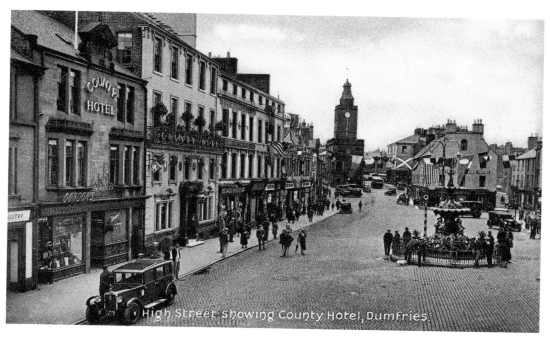

High Street showing County Hotel, Dumfries.

## High Street

Steps around the fountain provide an inviting place to sit – when it is sunny – and on the far side of the fountain are more benches in what is now a pedestrianised street. The building in the centre of the old photograph, behind the fountain, was the Temperance Hotel before being demolished to make way for the Burton's building which still occupies the site.

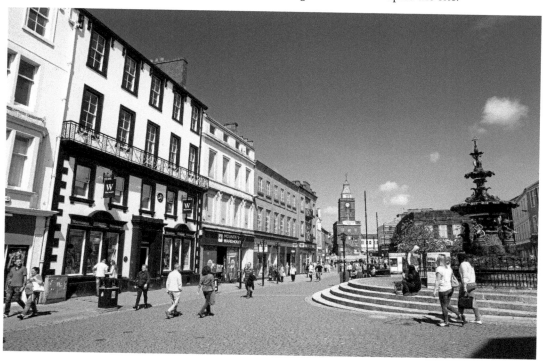

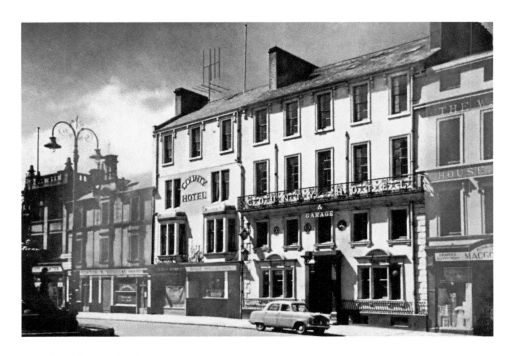

## County Hotel, High Street

The County Hotel was originally the eighteenth-century town house of Richard Lowthian, a Jacobite supporter who allowed Bonnie Prince Charlie the use of an upstairs room. The Prince demanded £2,000 and 1,000 pairs of shoes from the residents. The building had been known as the Blue Bell Inn, then the Commercial Hotel before it was the County Hotel. Room 6 was known as Bonnie Prince Charlie's room and rumoured to be haunted – perhaps because he departed with only 255 pairs of shoes and half the money. Now, only the façade is left of the once magnificent eighteenth-century building.

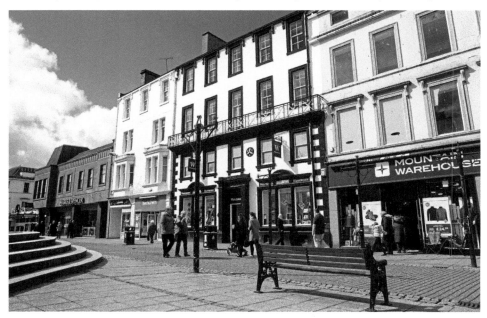

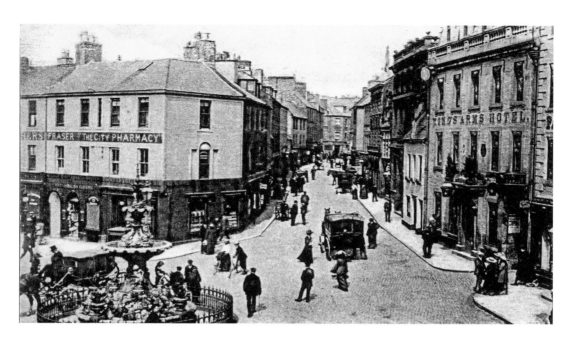

English Street, from High Street

A view taken around 1900 from the corner of High Street and English Street shows why English Street was considered to be one of the busiest streets in the town. People clearly had time to stop to chat to each other and the old photograph provides a good look at the fashions of the day.

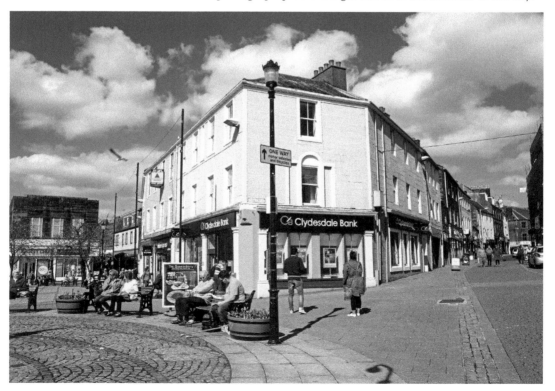

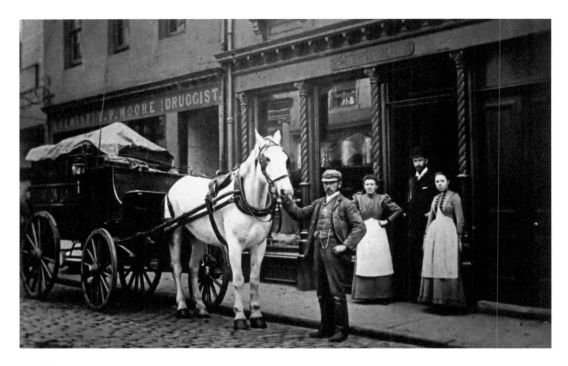

English Street

Changed scenes on English Street. The concept of a hair boutique would be astonishing to the nineteenth-century group, as would the change in fashions. The today photo is not of the former bakery with its horse-drawn deliveries but next door to include the barley sugar columns retained round the door and windows.

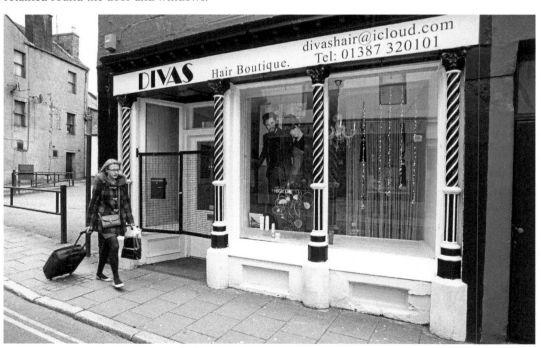

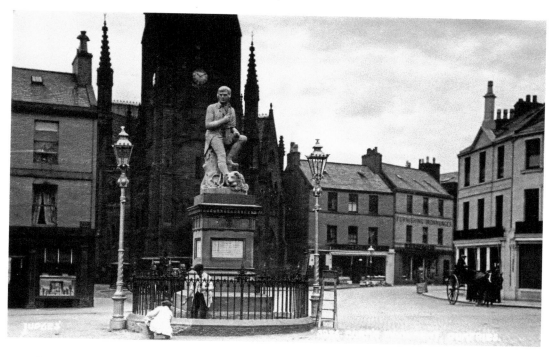

Burns Statue, Church Square

There is always maintenance to be done in the town centre, whether in the nineteenth or twenty-first century. Workmen paint the railings, which have now been replaced by flower beds and seating, around Burns Statue. The shops and houses on the left of the photo, near the Greyfriars Church, were demolished in 1937.

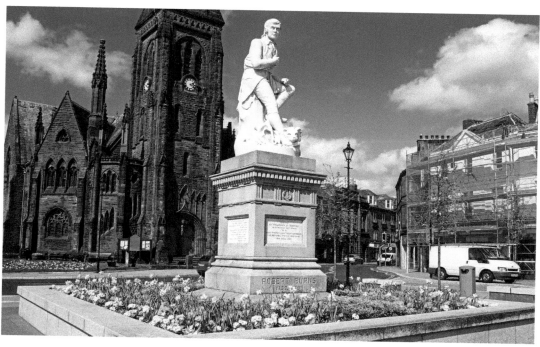

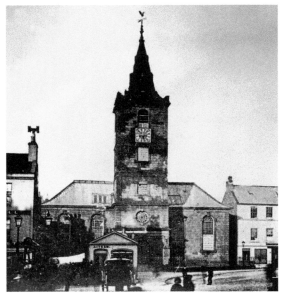

### New Kirk, Church Crescent

The New Kirk was built in 1727 on the site of Maxwell's Castle. In 1865, when the high cost of renovating the church was discovered, it was decided to demolish it and build a new church. The church, now called Greyfriars, opened in 1868. A number of buildings and gambling stalls were cleared away. At one time, a cannon from the Crimean War sat outside Greyfriars. It is now at the museum.

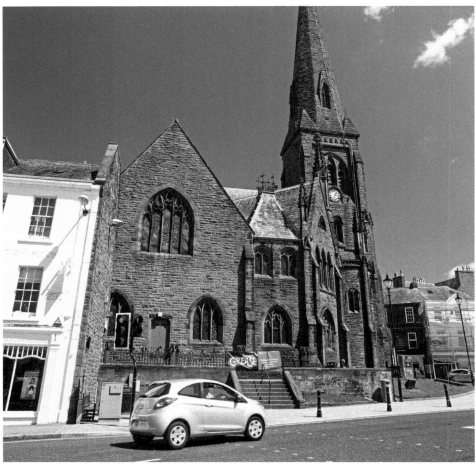

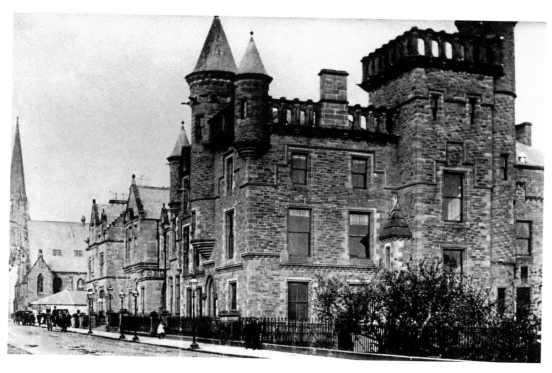

## Sherriff Court, Buccleuch Street

This typical Scots Baronial building, in the town's familiar red sandstone, was erected in 1863–66 and remains easily the most imposing building on the street. A pepperpot turret with projecting cannon waterspouts is above the front entrance. Apart from a plain twentieth-century extension the building has changed little. The street scene, however, is very different today.

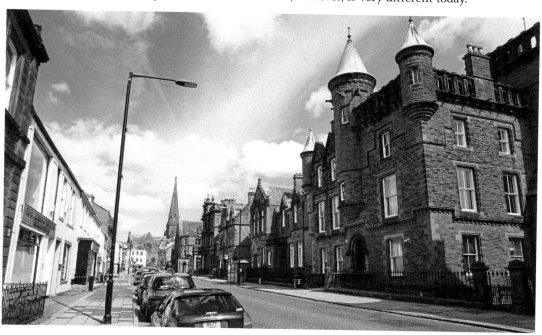

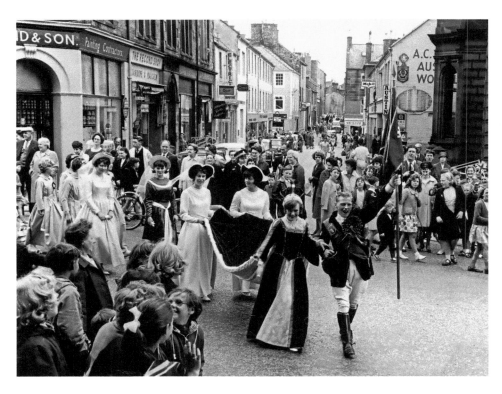

## Guid Nychburris Festival

A highlight of the festival is the coronation of the Queen of the South at the Midsteeple, before which the town clerk reads aloud the charter which made the town a Royal Burgh. The two queens in the photos were crowned in 1964 and 2014. Earlier in the morning the man chosen to be Cornet leads his followers in Riding the Marches, a symbolic ceremony checking the boundaries of Dumfries, which traditionally was to protect them from encroachment.

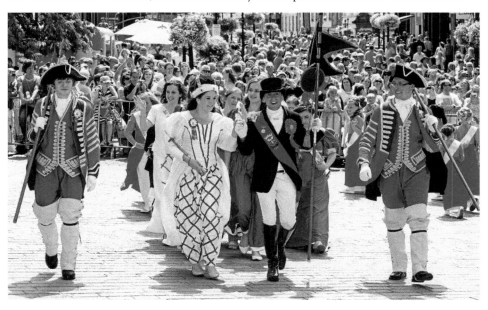

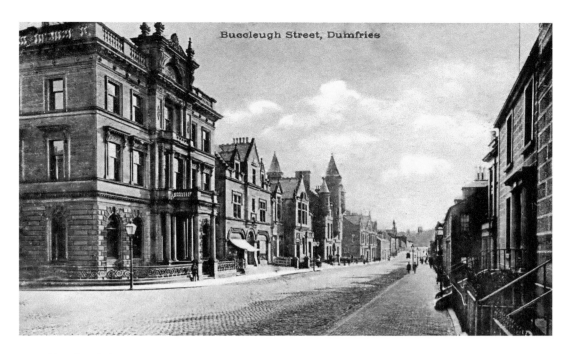

Buccleugh Street, Dumfries

### Buccleuch Street

Looking south towards the 'new' or Buccleuch Street Bridge, this was the town's most elegant street. Halfway down on the left can be seen the distinctive pepperpot turret of the Sherriff Court. Further up are premises once occupied by the Post Office and the large, ornate building on the corner with Irish Street, at one time the Clydesdale Bank, was built on part of the site of the Bridewell prison, demolished in the 1880s. Scotland's last public execution was held here in 1868.

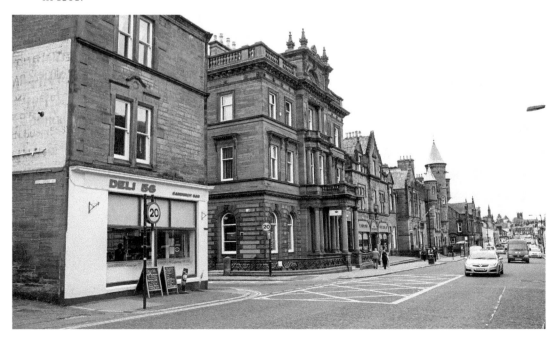

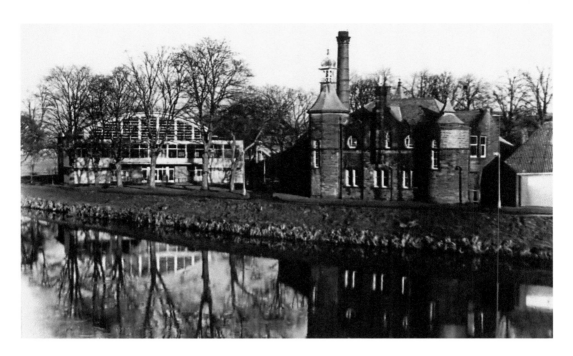

## Swimming Pool, Greensands

The old photo will evoke many memories for Doonhamers: the smell of chlorine, the footbath to walk through before reaching the pool, the glass sides, diving boards, warm children's pool. Opened in October 1963 with a swimming gala starring Olympic silver medallist Bobby McGregor, the pool was closed in December 2007. On the right, the *Dumfries Standard* and *Galloway News* office occupies space where the old steamie and public baths were.

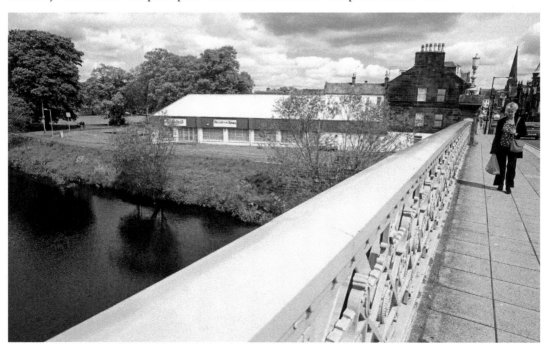

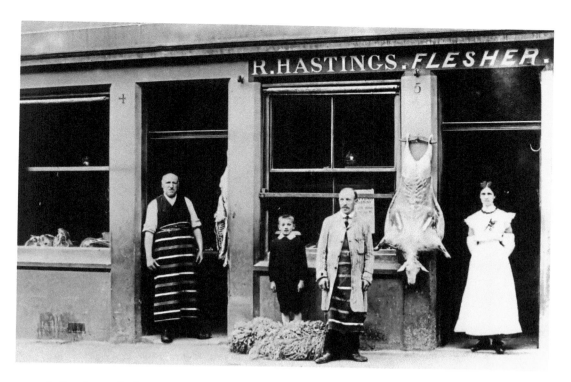

### R. Hastings, Flesher, 4 & 5 Glasgow Street

Somehow, despite its colourful appearance, Merlin office supplies (1–7 Glasgow Street) can't compete with the fascinating glimpse of how our meat was once sold. Today's environmental health officers would have a field day at a butcher hanging a sheep carcass outside, with another lying on the pavement awaiting butchery. On the other hand, the customer could be sure of what he was buying.

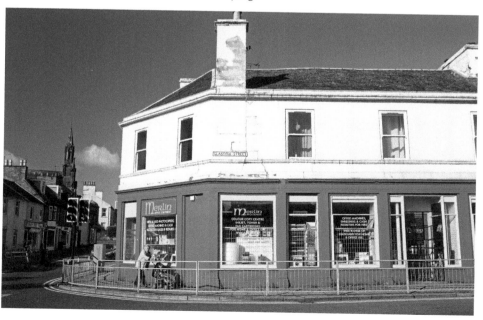

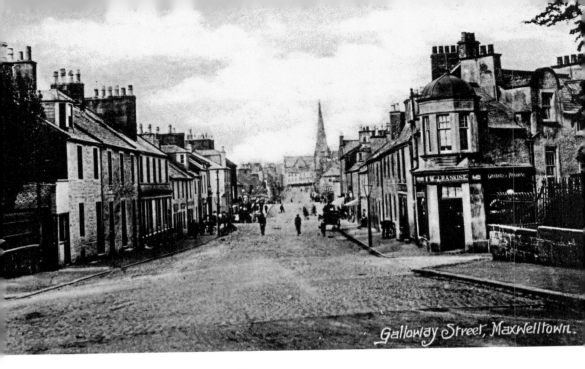

Galloway Street, Maxwelltown.

## Galloway Street, Maxwelltown, Dumfries

A late nineteenth-century photograph of Galloway Street, in what was then the burgh of Maxwelltown, looks towards Buccleuch Street. The cobbles have long gone, and the gas lighting, though the buildings have changed little. As can be seen by the volume of twenty-first-century traffic, Galloway Street is the main approach to the town from the west.

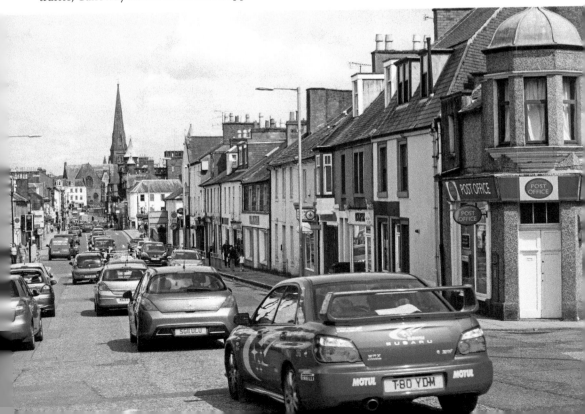

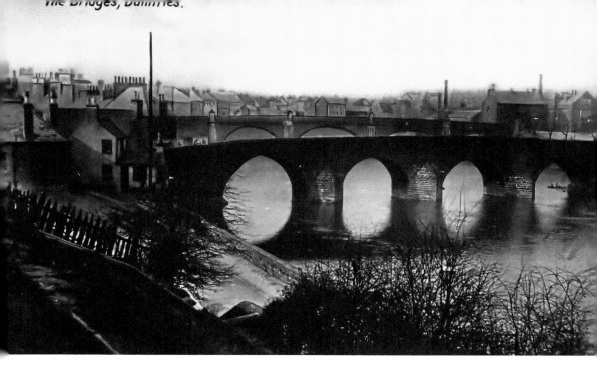

### The Devorgilla Bridge

Sometimes called the Old Bridge, Devorgilla Bridge is the oldest surviving multiple arched bridge in Scotland. Unsurprisingly, no traces remain of the first wooden bridge, reputedly built across the Nith by Lady Devorgilla in the thirteenth century. The sandstone bridge was built in 1431/2. In 1621 it suffered extensive flood damage and required major reconstruction, which resulted in a nine-arched bridge. When land on the east of the river was reclaimed three of the arches were removed and access from the Whitesands end was provided by a flight of steps.

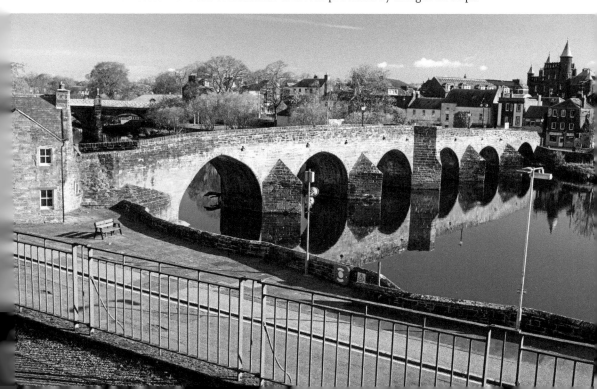

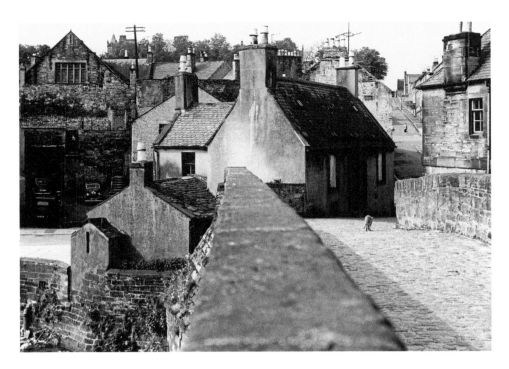

Old Bridge House, Devorgilla Bridge

Now a folk museum of everyday life, Old Bridge House at the Maxwelltown end of Devorgilla Bridge is the oldest house in Dumfries. Barrel maker James Birkmyre built it in 1660 into the sandstone of the bridge. Viewed from the bridge it seems to be only one storey but from behind can be seen to have two floors. During the 1700s and part of the 1800s it was an inn, possibly visited by Robert Burns when he was an excise man. It later became a family home and in the 1950s was converted into two flats before becoming the museum.

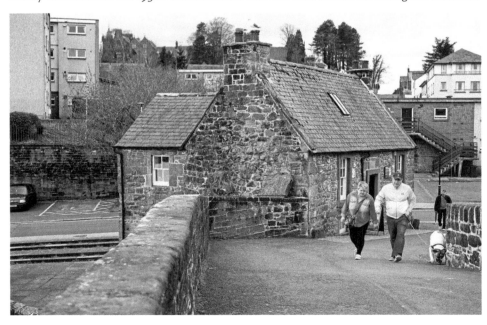

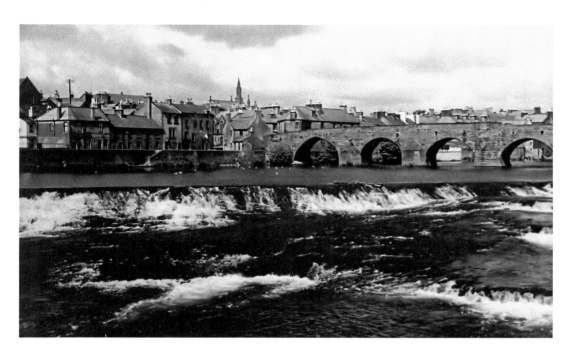

### The Caul, River Nith: from Whitesands

Looking across the river from the Whitesands, the contrast between then and now is quite dramatic with entire streets demolished to be replaced by modern blocks of flats. Originally called Brigend, it was in Kirkcudbrightshire and so outwith the jurisdiction of Dumfries. Being so distant from the nearest authorities it became a known hiding place for criminals. The village became a free burgh called Maxwelltown in 1810. Small industries sprang up, mills were built and new streets were laid out. The town council introduced a new housing scheme in the 1920s.

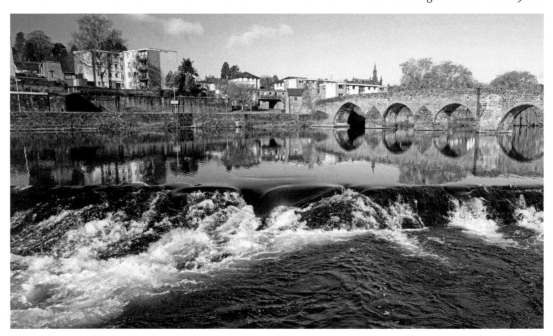

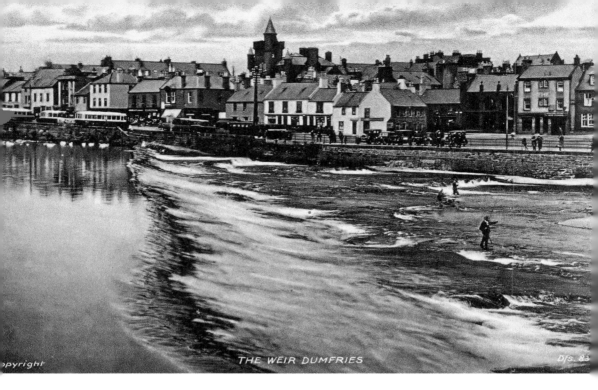

THE WEIR DUMFRIES

DfS. 83

## The Caul, River Nith: from Maxwelltown

In 1705, when the River Nith was causing erosion of the Whitesands, the weir, referred to locally as the Caul, was constructed. Matthew Frew's grain mill on the west bank made use of the diverted water. When in 1769 the mill was renewed, the Caul was strengthened and has changed little since. In the early twentieth century the mill was converted into a hydroelectric station providing sufficient power for electricity in the Troqueer area of Maxwelltown. The abandoned mill is now the Robert Burns Film Centre.

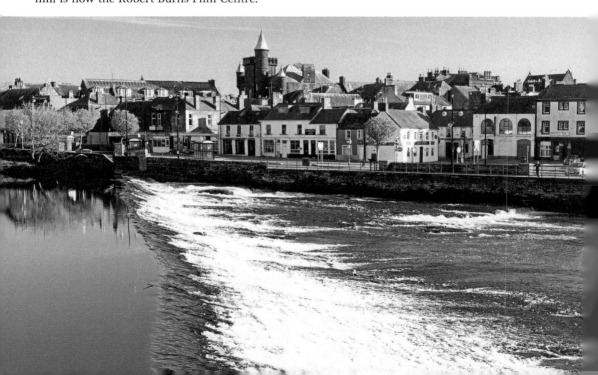

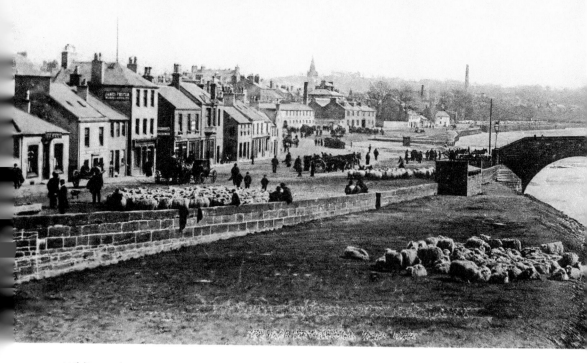

## Whitesands

Originally called the Lower Sandbeds during the town's time as a port; sheep were also brought to be sold on the Whitesands market, just above the Old or Devorgilla Bridge. A less cheerful bit of history occurred hereabouts in 1659 when ten women were found guilty of witchcraft by Dumfries Kirk Session and were taken to the Whitesands, strangled at stakes and their bodies burnt to ashes.

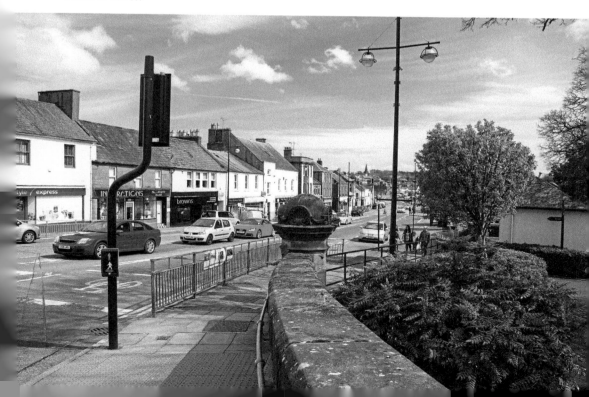

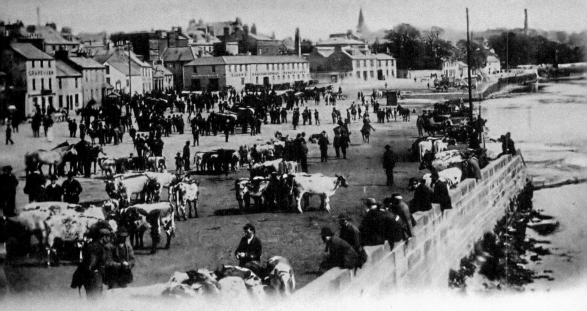

*The Sands, Dumfries.*

### Whitesands

Serious negotiations seem to be going on at this sale of cattle and horses in 1895. Livestock sales took place regularly here as Dumfries was allowed to hold two weekly markets and had a reputation for holding the greatest cattle market in Scotland. In those days drovers would take herds of cattle south on the drove roads. Droving ended with the coming of the railways. Despite the changes to the Whitesands seen below many of the buildings seen in the background still stand.

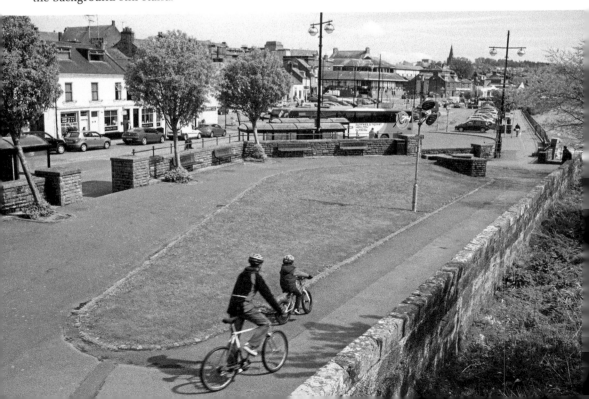

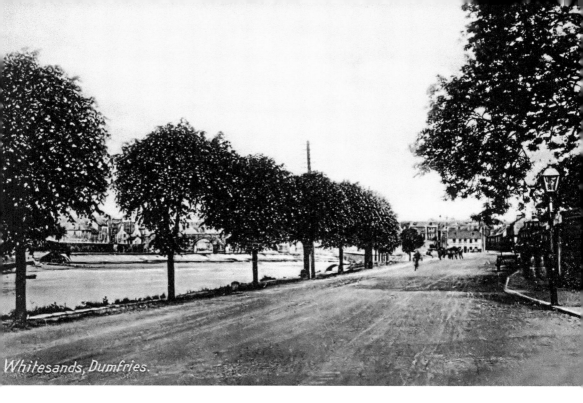

Whitesands, Dumfries.

## Whitesands

There is hardly any need for a caption for these two contrasting photographs. The tree-lined Whitesands along the River Nith is now a car park. Whenever plans are put forward to make this area a more attractive place for residents and visitors there is outrage at the prospect of car parking spaces disappearing.

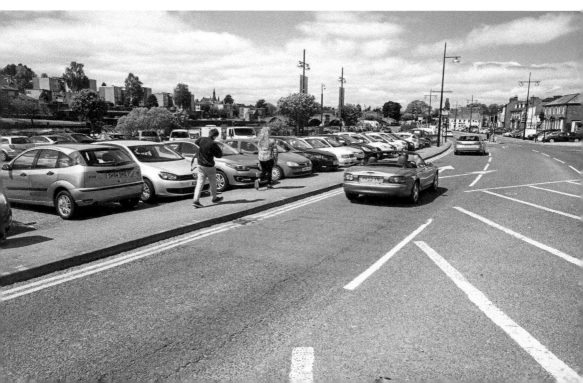

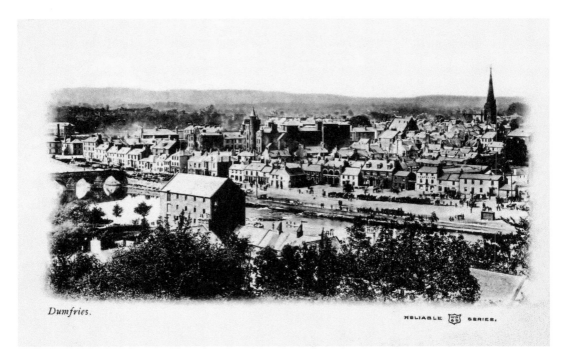

Dumfries.

### Dumfries, from Observatory

A nineteenth-century view of Dumfries from the Observatory in which landmarks can be identified such as the Devorgilla Bridge, the Sheriff Court and St Michael's church and, centre foreground, the grain mill which is now the Robert Burns Centre and Cinema. Satellite dishes sprout from houses today and on the horizon can be seen a row of wind turbines.

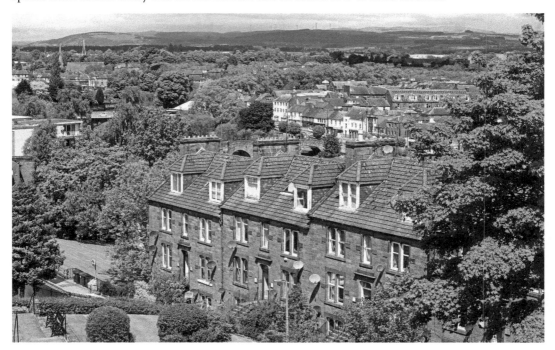

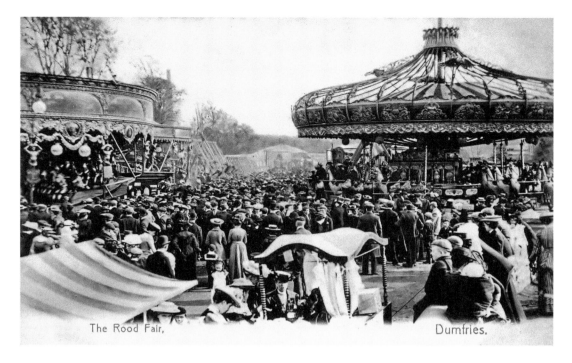

The Rood Fair, Dumfries.

## The Rood Fair, Whitesands

Around 1845, according to Donald Desmond's *Bygone Dumfries & Galloway*, the Rood Fair not only occupied Whitesands, its current location, but spread to Buccleuch, Castle and St David's streets with stalls lining High Street and Bank Street and more in Queensberry Square. They sold all manner of goods from china to cutlery and despite the ecclesiastical origins of the fairs there was gambling and much consumption of alcohol. Sideshows and the fairground rides, all that are left today, provided entertainment along with jugglers, acrobats and boxing rings.

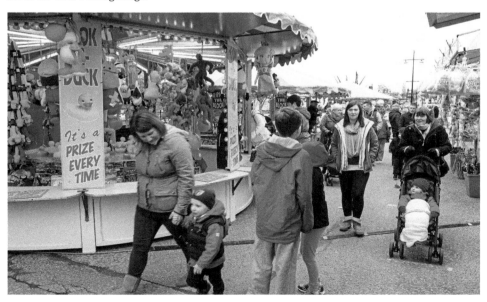

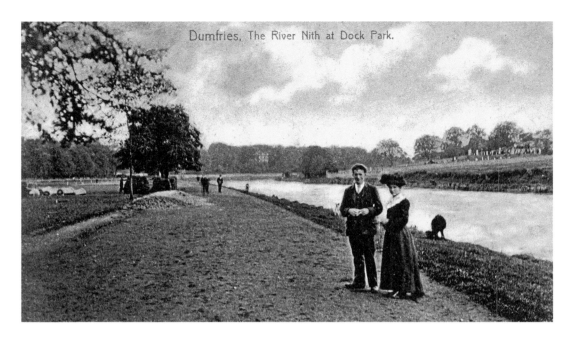

Dumfries, The River Nith at Dock Park.

## Dock Park, River Nith

Taking a stroll dressed in Sunday best: a young couple take the air in the oldest public park in Dumfries. The twenty-two-acre park was developed at the end of the nineteenth century beside the former Dockhead Quay. In 1913 a memorial to John Hume (band member) and Thomas Mullin (steward), lost with the *Titanic*, was unveiled. Even before the traditional Victorian-style park with bandstand, bowling and tennis, the park at Dock Park was let as an enclosed meadow for livestock. It recently underwent a major regeneration to upgrade the facilities, and reopened in April 2014.

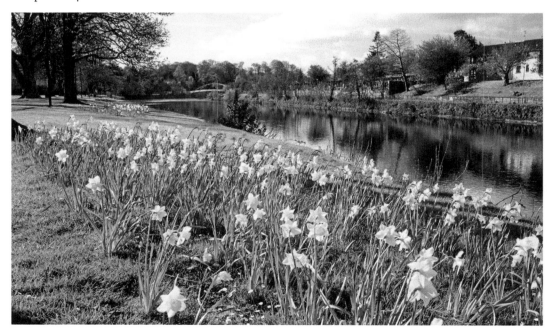

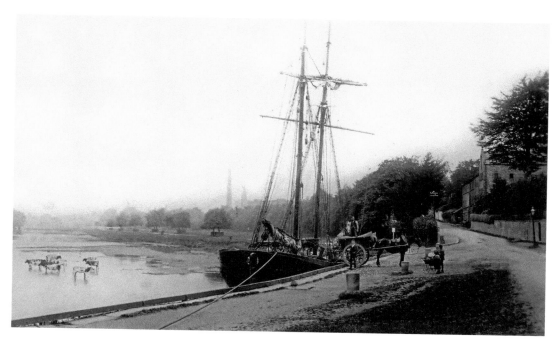

## Dock Foot

Once part of Dumfries Port, Dock Foot is now an entrance to Dock Park and it is difficult to imagine vessels carrying coal, timber, iron, slate and wine coming up the river to unload here or to take away wool, grain and freestone to Liverpool, Maryport or Whitehaven. The steamboat, *Countess of Nithsdale*, regularly sailed to Liverpool. Trade was at its peak in the 1840s but the railways, along with the cost of improving the channel, brought a decline in shipping.

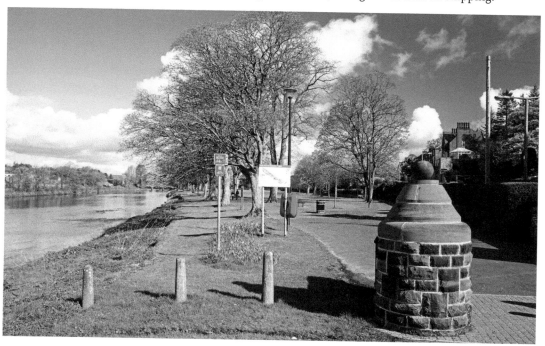

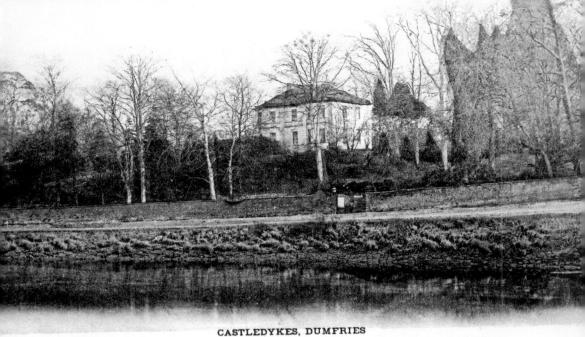

CASTLEDYKES, DUMFRIES
This modern mansion is built on the site occupied by the King's Castle of Dumfries,
all trace of which has now disappeared

## Castledykes Mansion

In 1821 Ebenezer Stott, a successful cotton trader, bought Castledykes estate where he built a mansion house with his wife Elizabeth, a keen gardener from Philadelphia. The gardens seem to have been truly remarkable. The house changed hands many times over the years until in 1901 Dumfries Burgh bought back the estate. The parks committee agreed to administer the estate in 1952, on condition the mansion was demolished.

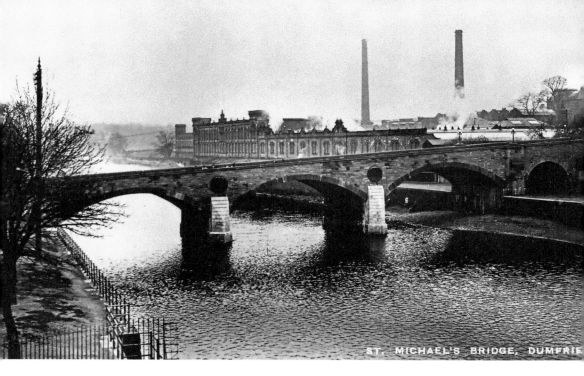

ST. MICHAEL'S BRIDGE, DUMFRIE

## St Michael's Bridge

Completed in 1927 the bridge, of reinforced concrete faced with sandstone, was officially opened by the Duke of Buccleuch in 1929. The road bridge was built to relieve traffic pressure on the Buccleuch Bridge. It linked Maxwelltown and Dumfries both physically and symbolically as the two burghs were formally joined the same year. The coats of arms of both burghs appear on the bridge. The disappearance of the mill chimneys completely alters the modern skyline.

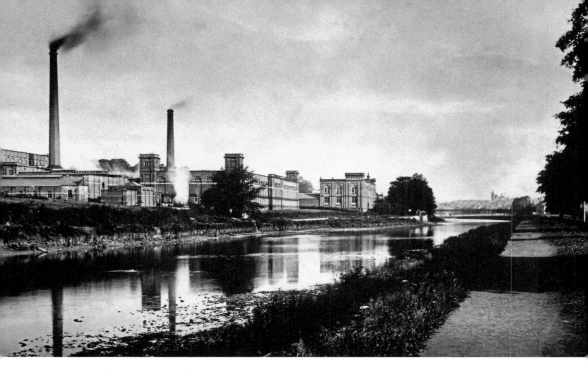

## Troqueer and Rosefield Mills

At one time, the mills were the largest woollen/tweed mills in Scotland, using 175,000 sheep fleeces a year. During the First World War they switched production to khaki and French army blue cloth but were unable to return to pre-war productivity. After a fire in 1923 Troqueer Mill closed and Rosefield closed before the Second World War. It was used as a recruiting station for the armed forces during the war. Rosefield Mill is now derelict and on the Buildings at Risk Register.

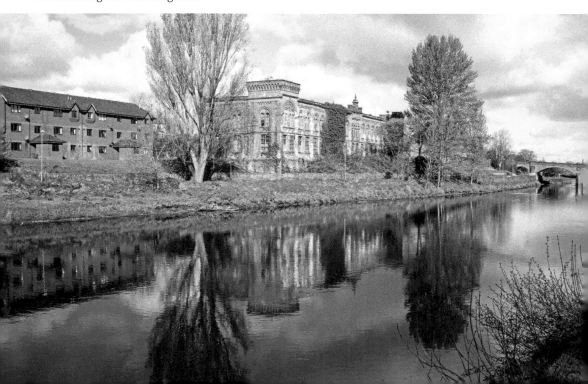

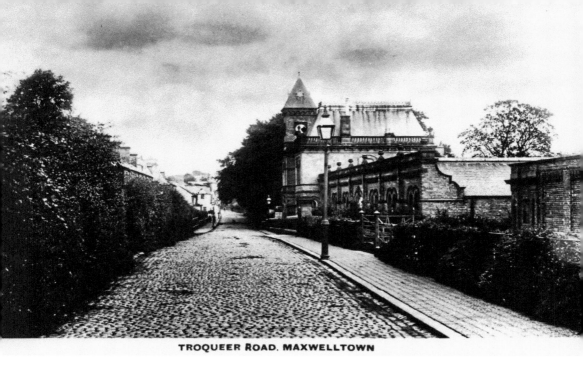

TROQUEER ROAD, MAXWELLTOWN

Troqueer Road, Maxwelltown
The Rosefield Mills, built in 1886, was once a thriving tweed factory providing employment to many in Dumfries. After the First World War the mill was unable to recover its pre-war markets and could or would not produce cheaper cloth. It was unable to survive the Depression. It is now on the Buildings at Risk Register and in a very poor state.

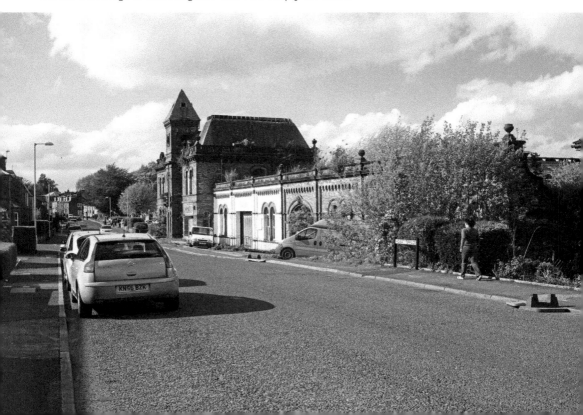

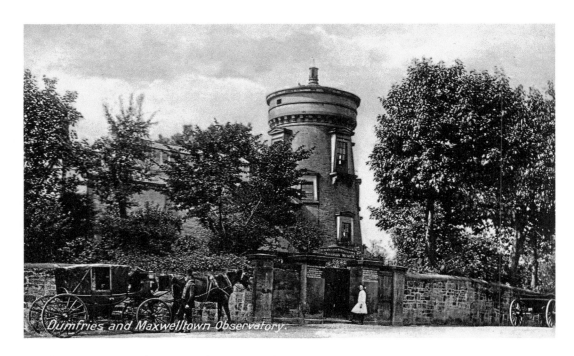

Dumfries Museum and Camera Obscura, Rotchell Road

What is often still referred to as the Observatory started life as a windmill in 1798. Dumfries and Maxwelltown Astronomical Society bought the site in 1834 and converted it into an observatory complete with telescope. The Camera Obscura based in the top of the windmill is the oldest working example in the world and has been in operation since 1836. The museum was built in 1862 to display the collections of the Dumfries and Galloway Natural History and Antiquarian Society.

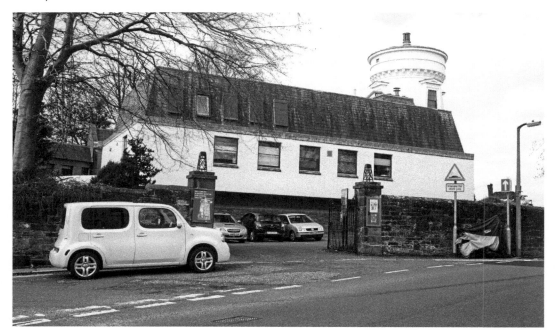

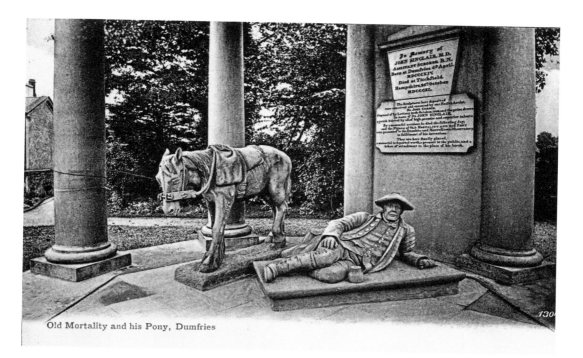

Old Mortality and his Pony, Dumfries

## Old Mortality, Dumfries Museum

The sculptures, by John Currie (or Corrie), are of Robert Paterson, known as Old Mortality, a stonemason who carved inscriptions for the unmarked graves of Covenanters killed in the seventeenth century. He features in Walter Scott's novel of the same name. Currie raffled this statuary group at 6*d* a ticket. The raffle winner was Dr John Sinclair, a young naval surgeon, who died in an accident, unaware he had won the prize. His family presented it to the Observatory.

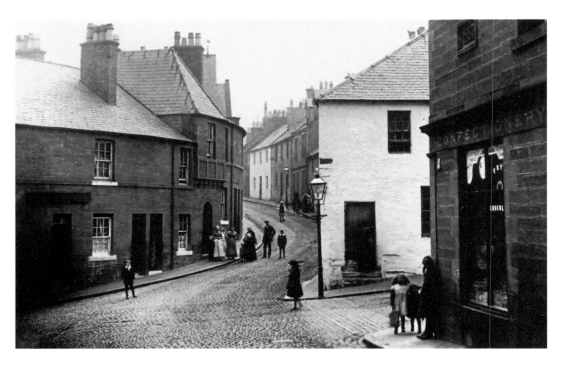

Church Street, Maxwelltown

The view of Church Street is almost unrecognisable today from when this fascinating photograph was taken in the early 1900s. The narrow road curves round, rising steeply towards the museum and observatory. The houses here with their interesting architecture have been replaced by blocks of flats.

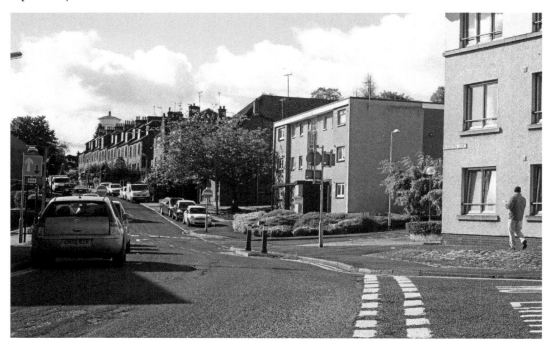

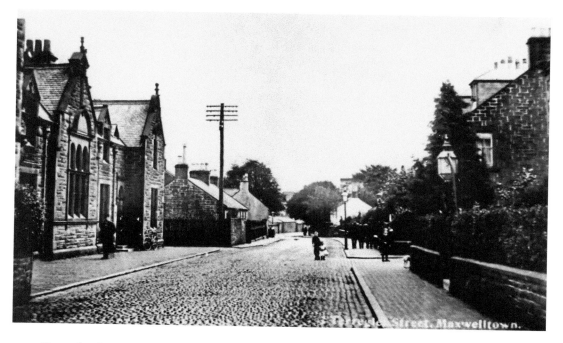

Terregles Street, Maxwelltown

In this view of around 1912 the prominent building on the left was multi-purpose, combining the court house, police station and cells, council offices and town hall. In many ways the outward appearance of the street has changed little, though there are no longer cobbles nor gas lamps.

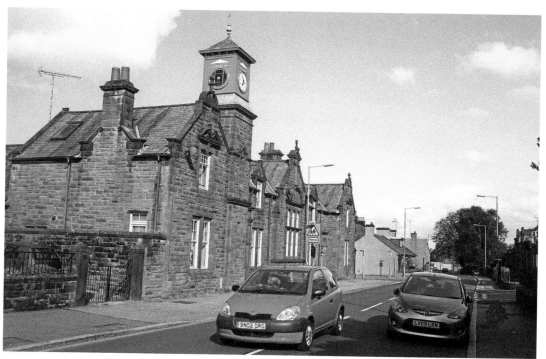

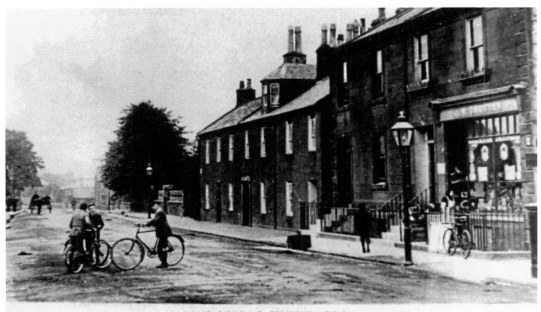

LAURIEKNOWE, MAXWELLTOWN.

**Laurieknowe, Maxwelltown**

No one on bicycles could pause for a chat in the middle of this road today. It is the main approach from the west and cyclists take their chances amidst the traffic. The shop on the right of the photograph is now a hairdresser's salon.

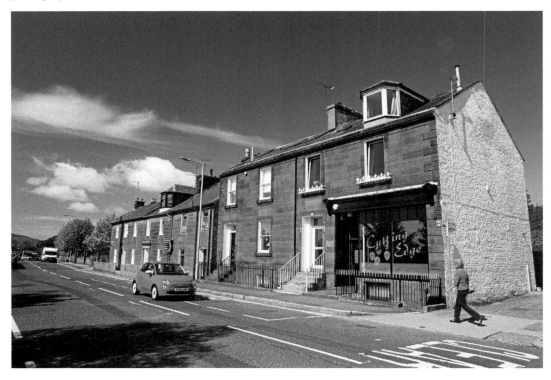

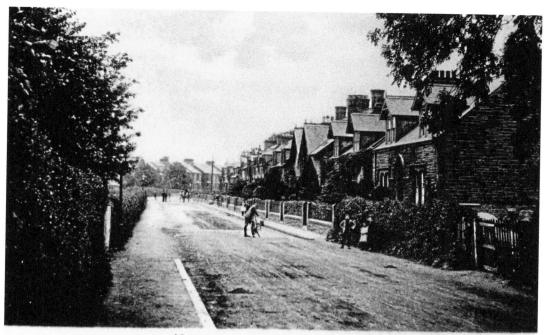

*New Abbey Road, Maxwelltown.*

## New Abbey Road, Maxwelltown

The road leading out of town towards New Abbey and the Solway Coast is not any wider now than it was in the old pre-vehicular traffic days. From the houses being of a fairly uniform appearance with the same front walls and hedges, they have now taken on a more individual look.

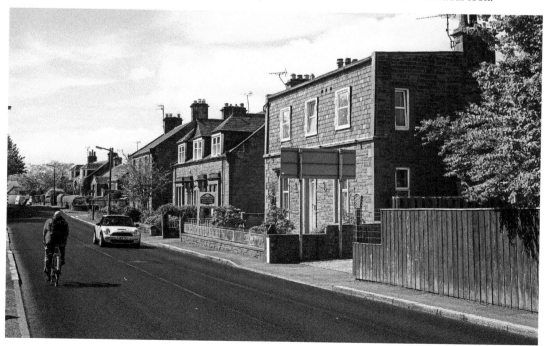

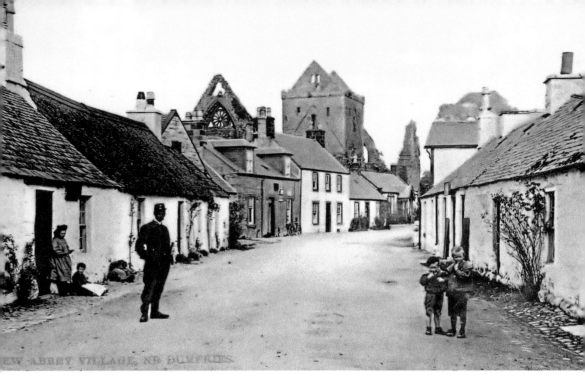

## New Abbey Village

The village took its name from the abbey founded by Lady Devorgilla, originally called the 'new' abbey to differentiate it from the Cistercian mother house at Dundrennan. The main road through the village, though better surfaced, remains as twisty as ever. The children outside the cottage on the left would probably not recognise the house today.

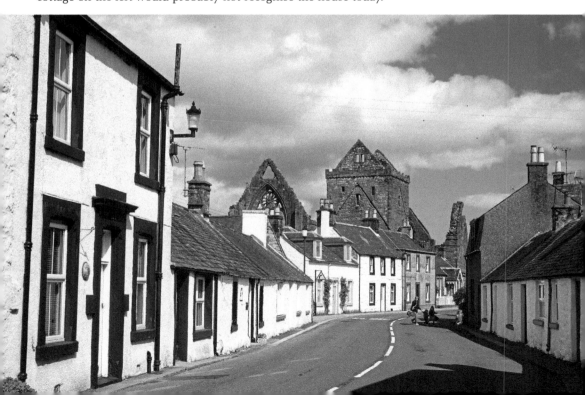

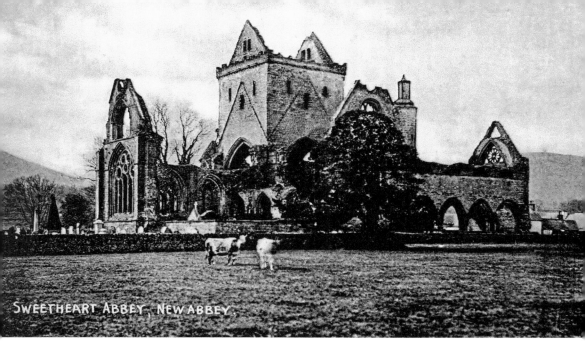

## Sweetheart Abbey, New Abbey

When Lord John Balliol died his grieving widow, Lady Devorgilla of Galloway, had his heart embalmed and placed in a casket which she always carried. In 1273 she founded a new Cistercian abbey in his memory and on her own death she, along with her husband's heart, was laid to rest in front of the high altar. This love for her husband led the monks to refer to the abbey as *Dulce Cor*, Latin for sweet heart. The graceful red sandstone ruins, with their romantic story, provide a popular wedding venue today.

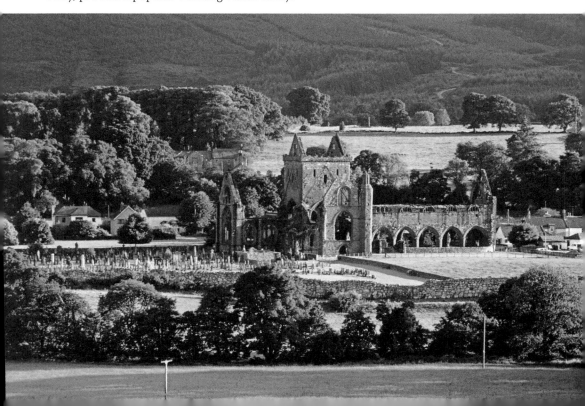

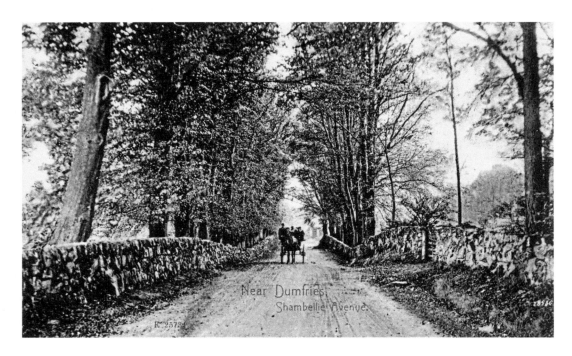

## Shambellie Avenue, New Abbey

The once fine drystone dyke along this tree-lined road towards New Abbey is now moss-covered and in need of some maintenance. Shambellie House was, until 2013, Scotland's Museum of Costume, housing costumes from through the ages, many collected by Charles Stewart whose family built Shambellie.

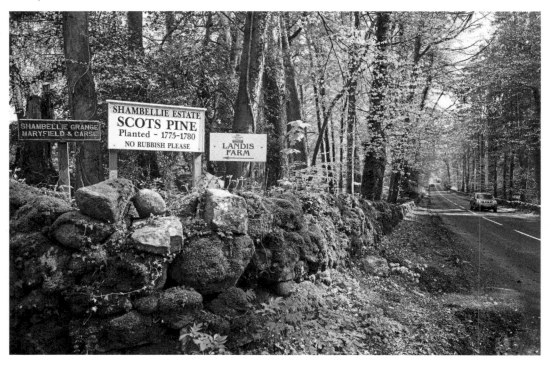

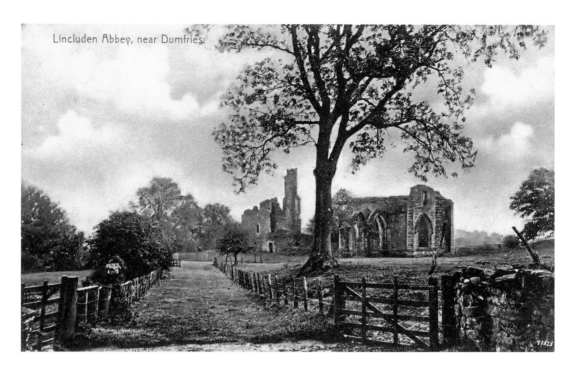

Lincluden Abbey, near Dumfries.

## Lincluden Collegiate Church, Lincluden

From 1160 a priory of Benedictine nuns was here until 1389, when Archibald, 3rd Earl of Douglas, sought permission from the Pope to replace the priory with a college of canons. The buildings were in disrepair and he hinted at the nuns' moral decay. During the Reformation the collegiate church was attacked and damaged but repaired. By 1700, though, it had been abandoned and used as a quarry. It is looked after by Historic Scotland. A highlight is the elaborate tomb of Princess Margaret, daughter of Robert III.

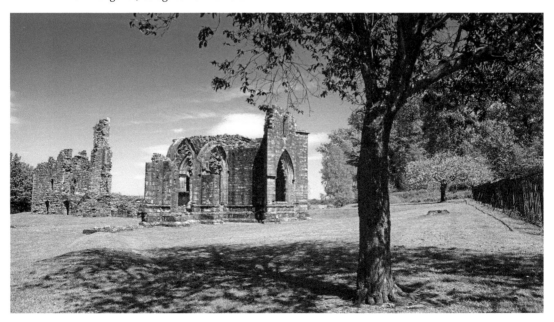

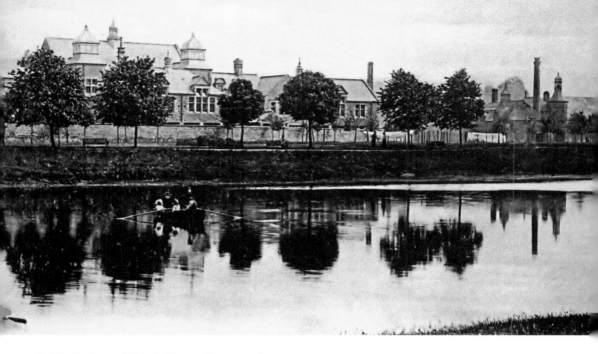

**Public Baths and Wash-House, Greensands**

Miss McKie of Moat House donated the public baths and wash-house – traditionally referred to as a steamie. Miss McKie also gave the land for the Ewart Library and funds for the widening of the Buccleuch Street Bridge. The wash-house stood on the Greensands until it was demolished in 1973.

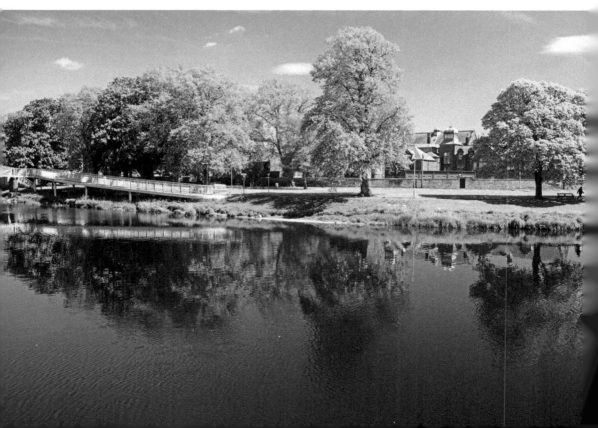

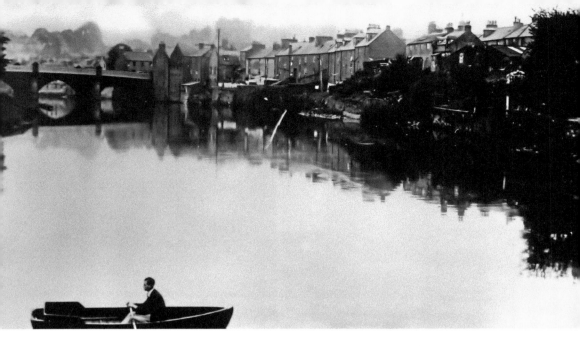

### River Nith, Towards Buccleuch Bridge

A lone rower enjoys the peaceful River Nith above the Buccleuch Bridge which was completed in 1794. In the twentieth century the volume and weight of traffic increased greatly and the bridge had to be widened and strengthened in 1935. The appearance of Glasgow Street on the opposite bank has completely changed with the disappearance of the houses backing onto the river.

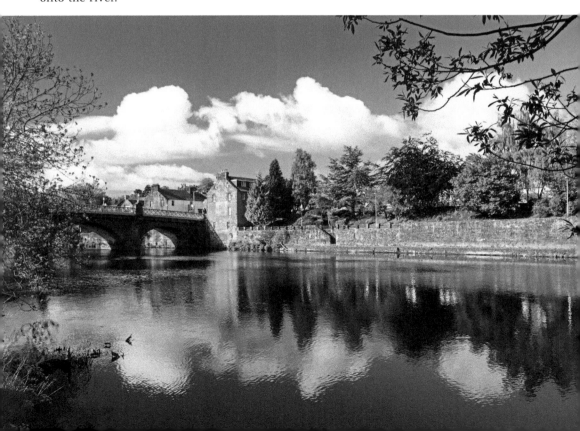

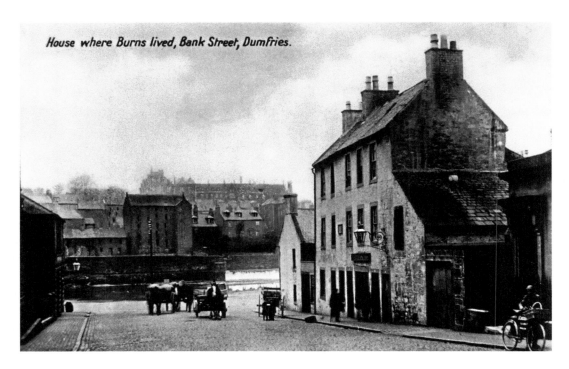

House where Burns lived, Bank Street, Dumfries.

Burns House, Bank Street

When poet Robert Burns became an excise man and left Ellisland Farm at the end of 1791 he moved his family into a two-roomed flat here, close to the Nith. His excise superior and friend, John Syme, occupied an office below. Bank Street was known as the Wee Vennel or, thanks to the open sewer running down it, the Stinking Vennel. Promotion in 1792 to the Dumfries Port Division gave Burns more free time which he put to use in writing some sixty songs and poems.

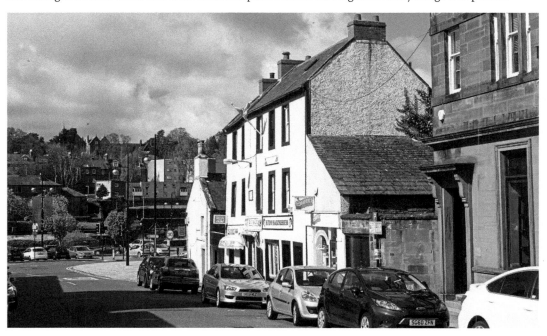

THE MECHANICS' INSTITUTE, DUMFRIES

The Dumfries and Maxwelltown Mechanics' Institute, St Michael Street and Nith Place
The building was once the town house of the Stewarts of Shambellie before it became home
to the Mechanics' Institute. Dr Browne, medical superintendent at the Crichton Royal Hospital,
was its president for a time. It had a reading room, 8,000-volume library and lecture hall.
Courses of lectures were held during the winter and classes for boys who had missed out on
education. It was demolished in 1966.

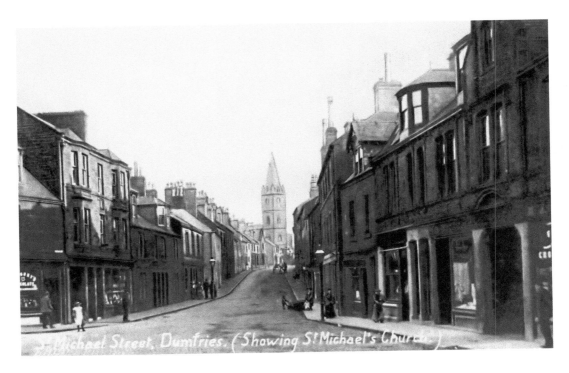

St Michael Street, Dumfries. (Showing St Michael's Church.)

## St Michael Street

Looking up towards the iconic landmark of St Michael's church, named after the patron saint of Dumfries, in contrast to the nineteenth-century scene the street now has a constant flow of one-way traffic. Although the buildings on the left are recognisably those in the old photo, on the right many changes can be seen; some buildings have gone, as have the high chimneys towering over the rooftops.

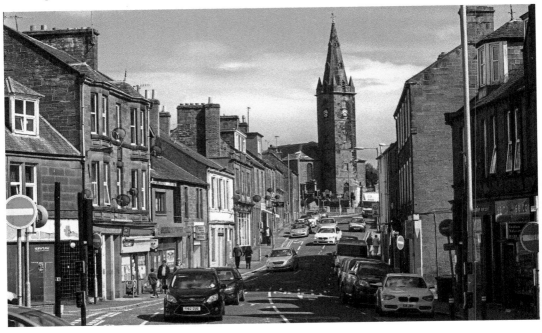

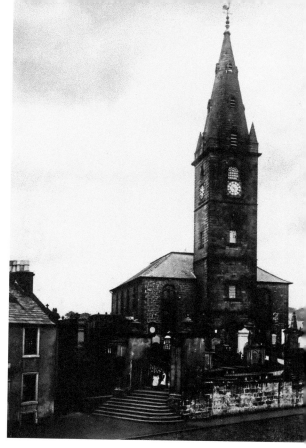

### St Michael's Parish Church, St Michael's Street

Two previous churches occupied the site before this one, which was built between 1741 and 1746. Ten stone pillars supporting the roof are from the earlier church and date back to around 1500. On one is a brass plaque indicating the site of the pew occupied by Robert Burns and his wife Jean Armour. The church and the graveyard, which contains Burns' Mausoleum, are both Grade A listed. The vintage car in the foreground provides a quirky touch to the today photo.

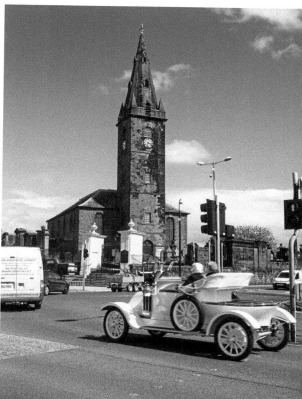

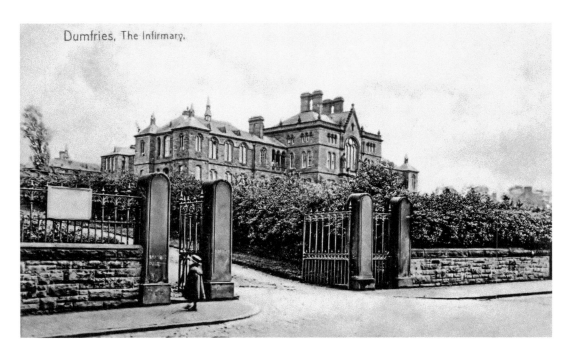

Dumfries, The Infirmary.

## Nithbank, St Michael's Road

A fine Italianate building, built in 1873 to replace the previous infirmary, which had opened in 1778, Nithbank was the third of four successive infirmaries in the town. The new hospital had 100 beds and it was here the first operation using ether as an anaesthetic was performed, on 19 December 1846, two days before Liston in London. Nithbank served until the present day infirmary was opened in 1975. A new hospital, the town's fifth, is currently under construction.

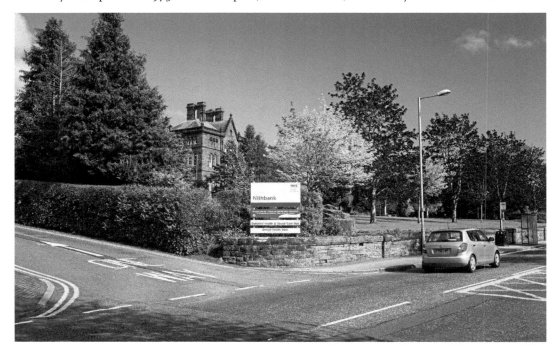

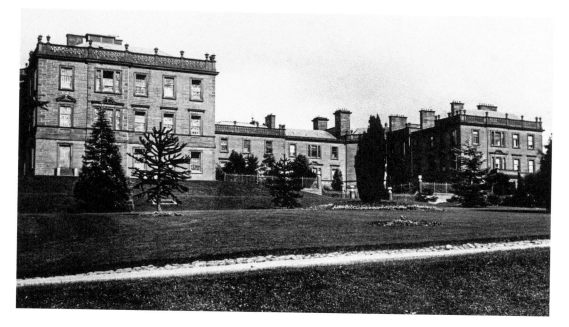

## The Crichton Royal Institution, Bankend Road

Founded in 1839, the Crichton became the leading mental health hospital in the country. The first Medical Superintendent, Dr W. A. F. Browne, introduced activities including a patient magazine, theatrical productions, sports events and outings. Patients worked on the hospital farm, in the laundry and gardens. The hospital was practically self-sufficient with its own water supply, bakery and fire service. The hospital became part of the NHS in July 1948 and through the 1970s and 1980s it was scaled down, the last patients leaving the site in 2011.

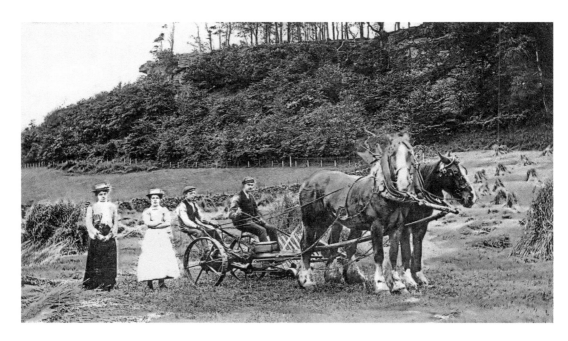

## Maidenbower, Georgetown

In this traditional harvest scene, the two women's smart clothing makes it unlikely they have been raking hay into stooks. The rocks glimpsed at the top of the photo were supposedly once a Druid site with a narrow passage between them used as a chastity test. Later custom held that in May any young girl who succeeded in squeezing through the narrow passage had to pay a forfeit of a kiss. Today a multi-use path links Georgetown with the Crichton Business Park.

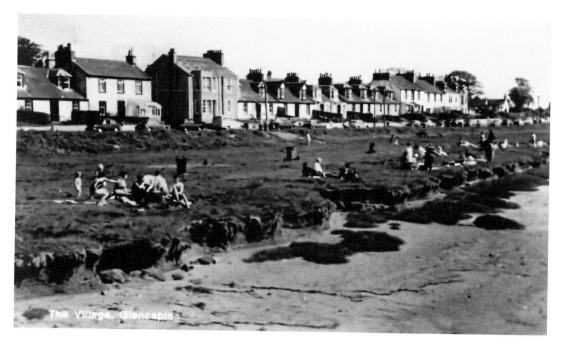

The Village, Glencaple

## Riverbank, Glencaple

A shot from the 1960s shows how popular the riverbank in Glencaple was, with people coming to enjoy picnics along the bank and splashing in the River Nith. From the number of cars parked along the road many probably came out from Dumfries. The village shop and tea room are in a building inspired by its maritime surroundings with the curved roof reflecting the Nith tidal bore and the incorporation of port holes a reminder of the shipping which plied the river.

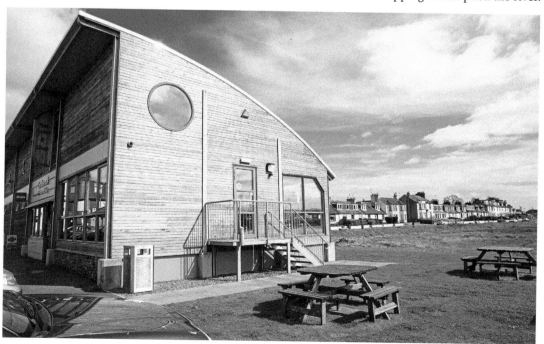

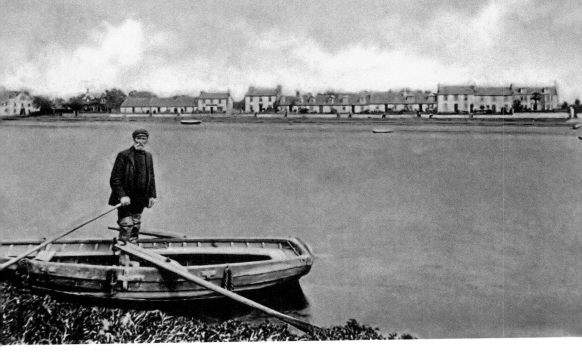

### Glencaple Village

An old ferryman waits for customers across from the village which sits on the banks of the River Nith. It was once part of Dumfries Port after the Earl of Nithsdale gave land and stone for its construction, in return for free passage of his goods over Dumfries toll bridge. Imports included tobacco, lime, coal, timber, dried fruits and rum. In the 1800s emigration to Canada increased and ships left carrying passengers, returning with timber and salt fish.

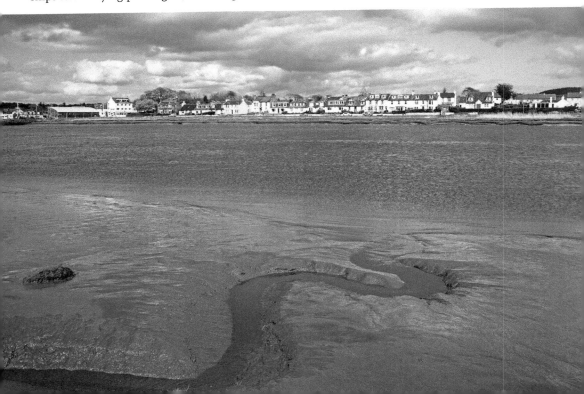

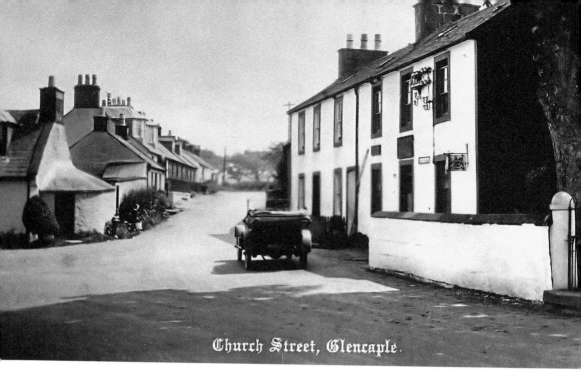

Church Street, Glencaple.

## Church Street, Glencaple

Described in 1882 as having a 'tidy and cheerful appearance', much the same could be said of Glencaple village in 2015. Situated on the left bank of the Nith, five miles from Dumfries, it was once part of Dumfries Port. The house on the right foreground was the post office and telephone exchange.

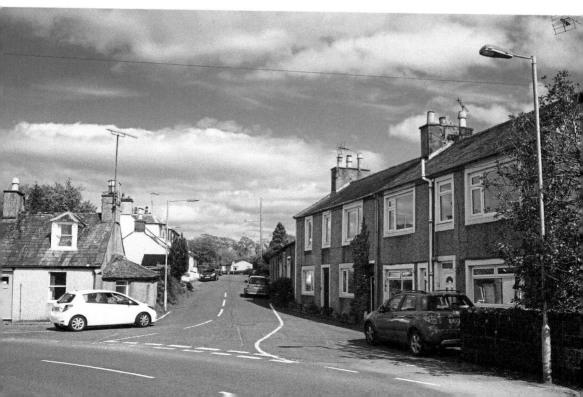

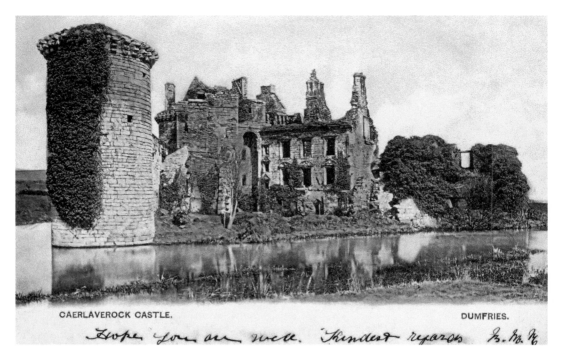

CAERLAVEROCK CASTLE.                                       DUMFRIES.

*Hope you are well. Kindest regards B. M. W.*

## Caerlaverock Castle

Built in the 1270s, with its moat, twin-towered gatehouse and battlements, Caerlaverock is one of Scotland's most imposing medieval castles. The triangular arrangement of its red sandstone defensive walls is unique in Britain. With its proximity to the English border the castle has had a turbulent history over the centuries and even when the wars with England ended, religious wars began with Covenanters besieging the castle in 1640. Much of the damage which can be seen today was caused at that time.

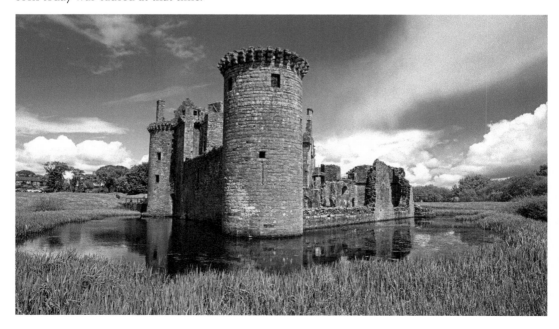

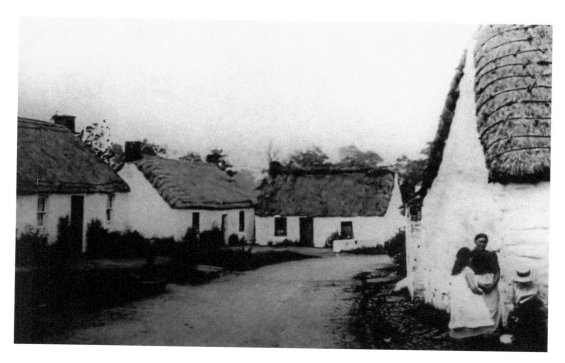

## Bankend Village, Dumfries

The rustic scene of thatched country cottages is no more. They would once have lined the road seen in the today photograph: some have been demolished, others modernised and made bigger. The view is from the bottom of the village, which is in the parish of Caerlaverock, and the road curves round to then go over a bridge. The telephone box is now an information centre. Robert Paterson, Walter Scott's Old Mortality, is buried in the kirkyard.

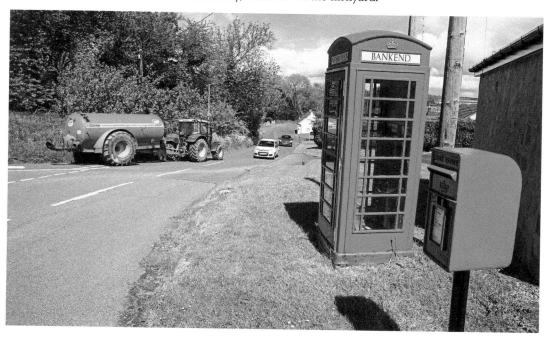

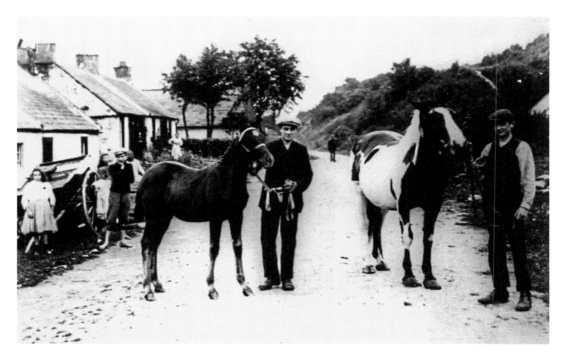

Smiddy, Georgetown

Once a village, Georgetown is now a suburb of Dumfries. The difference in appearance between the nineteenth century and now could not be more marked. While the main focus of the photograph is the men with their horses, the photographer has captured more details of the cottages and the people. In the new photo, traces of the old country cottages can still be seen.

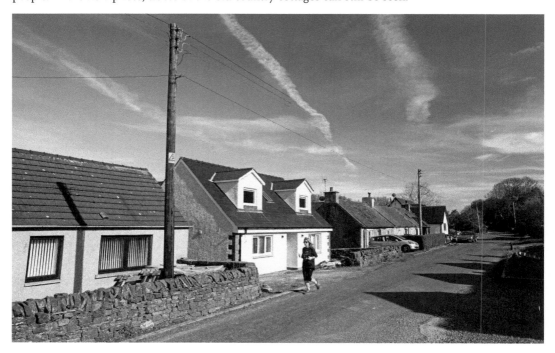

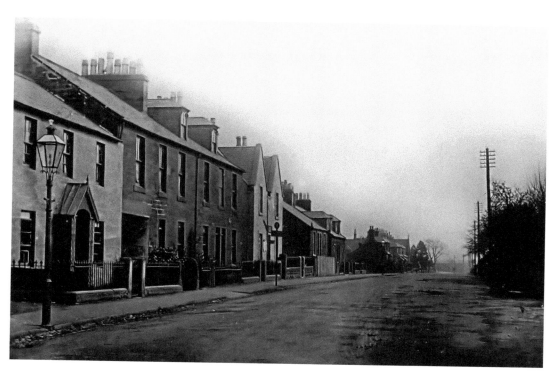

## Noblehill, Annan Road

Before the town's bypass in the early 1990s, the Annan Road was one of the busiest routes into the town. While the street lighting was still gas lamps, the telegraph poles indicate a move into modern times. On the left in the old photograph, one of the buildings is now a mosque. In the new photograph, the road on the right from the roundabout leads to Georgetown.

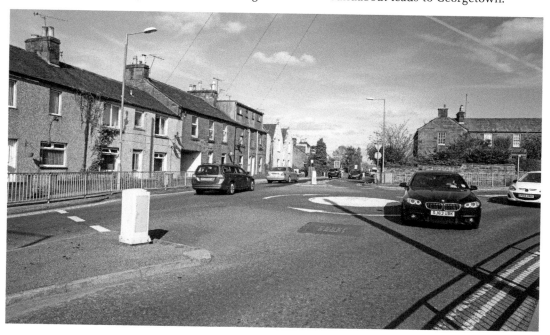

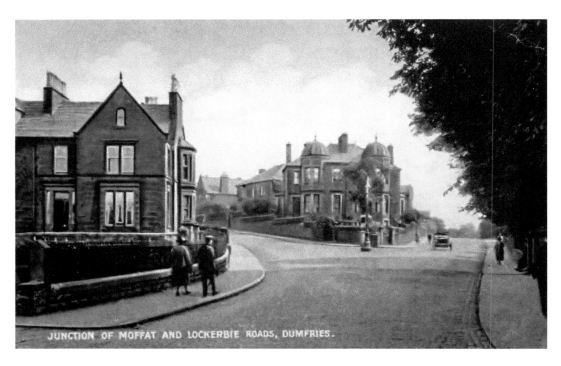

JUNCTION OF MOFFAT AND LOCKERBIE ROADS, DUMFRIES.

## Moffat and Lockerbie Roads

The introduction of lane markings, traffic islands and a mini-roundabout indicate how much more traffic is on these roads today. A bowling green is on the Moffat Road, on the left. The road to the right leads to Lockerbie.

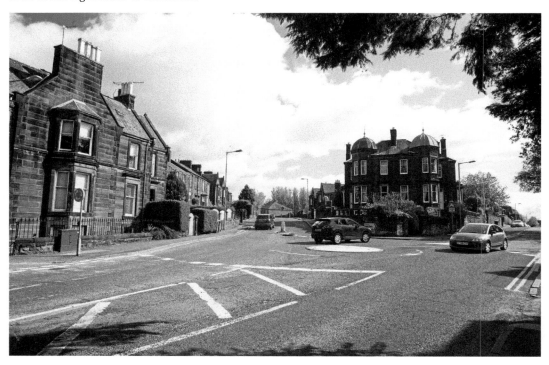

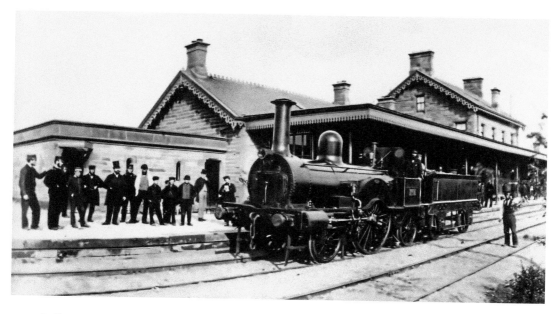

**Railway Station**

Perhaps the flower planter modelled as a steam train on the platform today indicates a hankering for the olden days of railway journeys. The first link to the rail network for Dumfries was the opening of the line to Gretna in August 1848. At one time there was an amazing rail network throughout the region and beyond, which proved crucial to the plot of Dorothy L. Sayers's well-known detective novel *The Five Red Herrings*. Dr Beeching, of course, saw to the end of local rail travel.

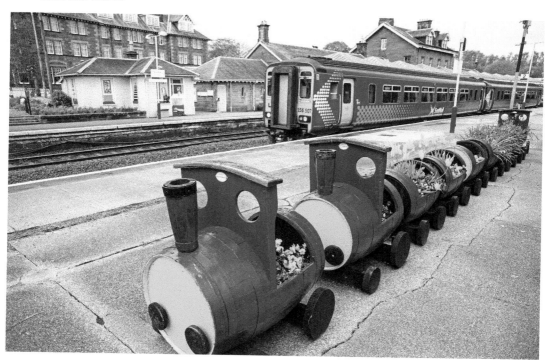

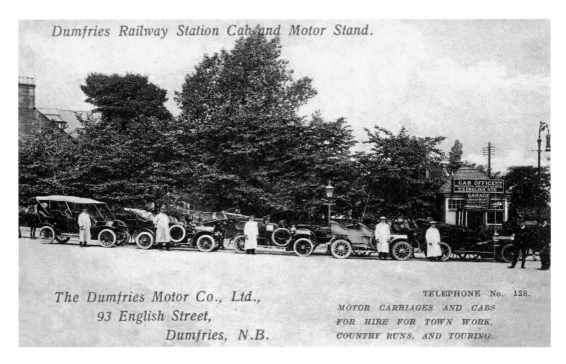

*Dumfries Railway Station Cab and Motor Stand.*

The Dumfries Motor Co., Ltd.,
93 English Street,
Dumfries, N.B.

TELEPHONE No. 128.

MOTOR CARRIAGES AND CABS
FOR HIRE FOR TOWN WORK,
COUNTRY RUNS, AND TOURING.

### Dumfries Cab Office, Railway Station

Although the cab office still stands, if looking rather dilapidated, the scene today is very different from when a row of smart cabs lined up for hire outside the station. A 'country run' would be a pleasure in one of these, with a smartly turned-out driver at the wheel.

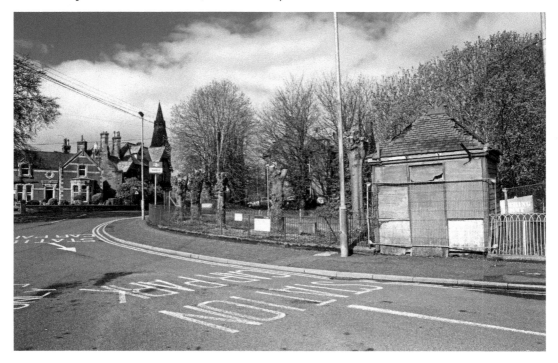

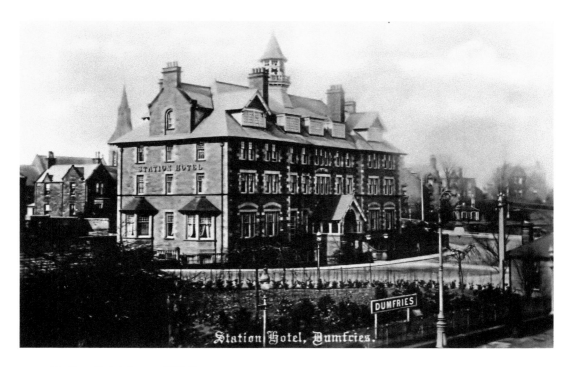

Station Hotel, Dumfries.

### Station Hotel, Lovers' Walk

Directly opposite Dumfries railway station, the hotel was built in 1896–97 in the days when Britain's private railway companies pioneered the idea of railway hotels. When the railways were nationalised in 1948 the hotel was taken over from the London, Midland & Scottish Railway as part of a portfolio of British Transport Hotels. Sold in 1971, it is now a Best Western Hotel offering flat screen televisions and Wi-Fi – amenities undreamt of in Victorian days.

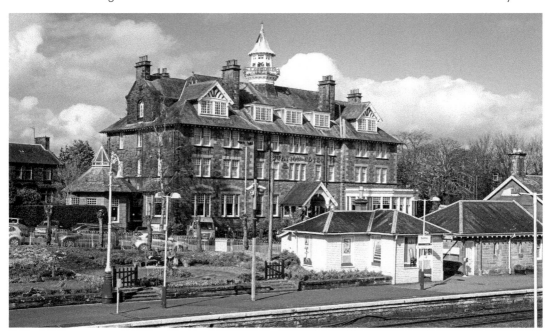

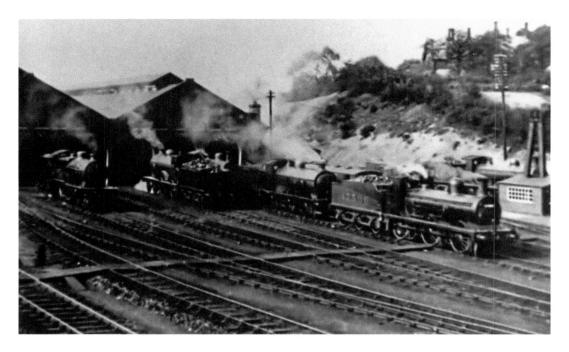

## Locomotive Sheds near Cornwall Mount

The engine shed was between St Mary's Street Bridge just south of the station and the Annan Road. The house glimpsed on the high ground above the loco shed was Cornwall Mount, demolished along with Mount Pleasant when the new road was built to link St Mary's Street and Annan Road. The police administration headquarters at Cornwall Mount opened in 1993. The control room was closed in 2014 and now in 2015 there are talks of the headquarters being sold to save money.

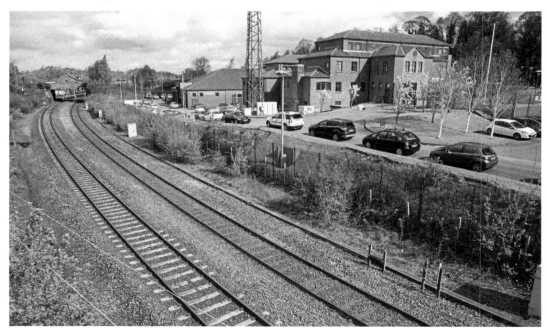

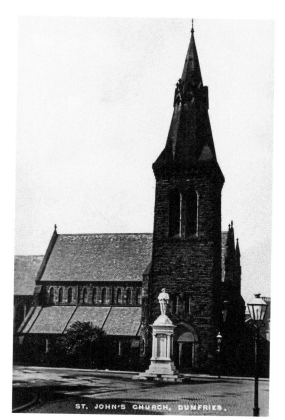

**ST. JOHN'S CHURCH, DUMFRIES.**

**St John's Church, Newall Terrace**
Before building this late nineteenth-century church, the congregation met in one dedicated to St Mary built on the corner of Buccleuch Street and Castle Street – now the Robert the Bruce pub. They sold that church, often referred to as the 'English chapel', to the Wesleyan Methodists in 1862. The new church was built in the Church of Scotland parish of St Mary's so another name had to be found and St John was chosen. A granite war memorial stands outside the church.

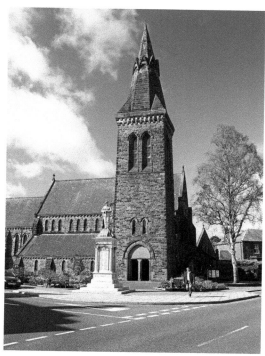

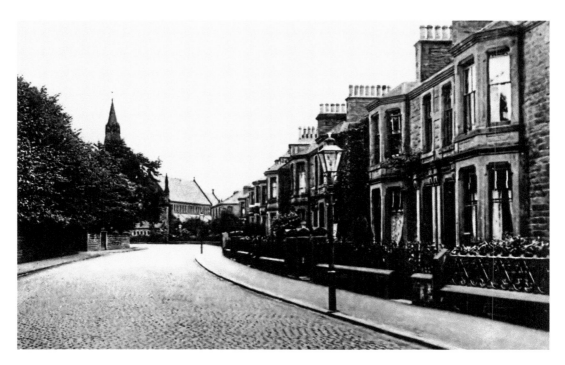

Lovers' Walk

Looking from the Edinburgh Road end of the street towards St John's Church. The road continues round to the left towards the railway station and is no longer the quiet suburban street of old. Although the buildings on the right have not changed much, the old gas lamps and cobbles are long gone. Lovers' Walk is home to the Dumfries BBC studios.

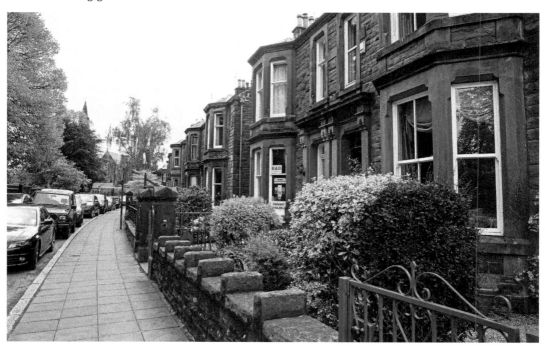

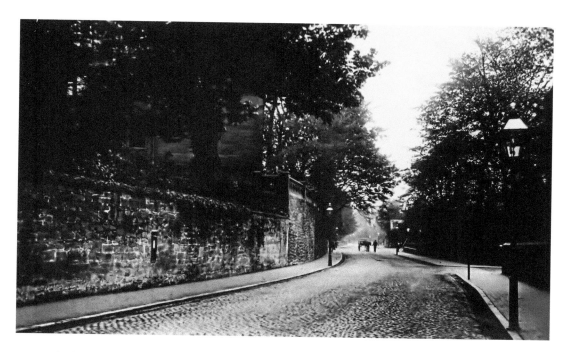

Edinburgh Road

Traffic lights are required at this busy junction on the Edinburgh Road. It looks very different from the nineteenth-century view with the cobbled road, gas lights and a solitary horse and cart. On the left wall can be seen a post box. The building which can just be seen behind the wall was the Moat Hostel, home for young female students at the Academy.

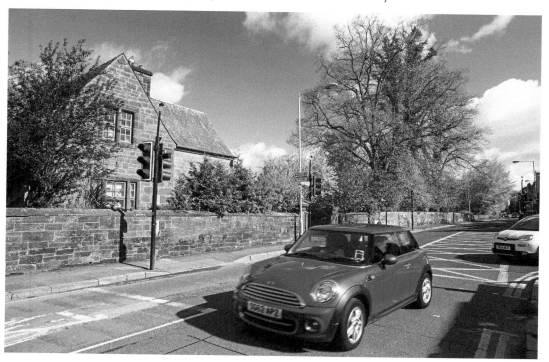

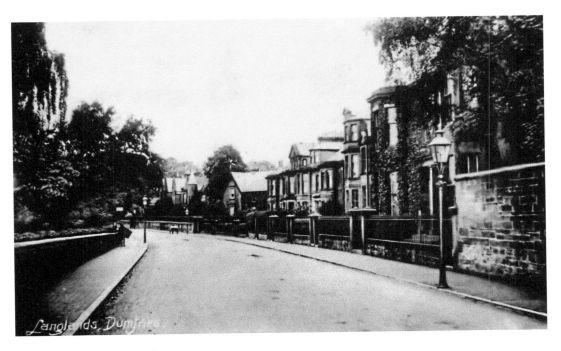

Langlands, Dumfries

### Langlands, Edinburgh Road

Still a leafy, tree-lined road, the houses are close to the River Nith, which is on the left. One of the most obvious changes here is electric street lighting replacing the old gas lights – and of course the amount of traffic on what was once a quiet thoroughfare.

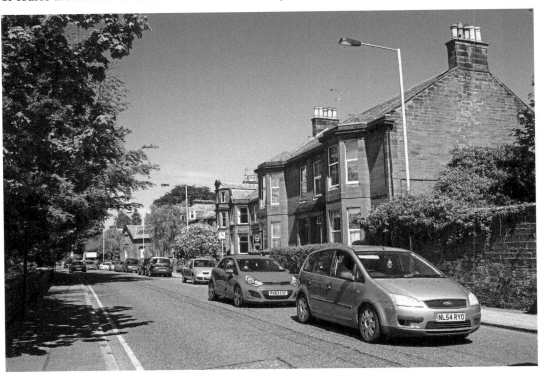

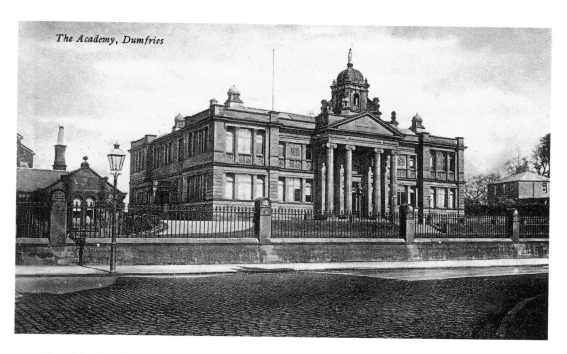

*The Academy, Dumfries*

## Dumfries Academy

Begun in 1897, the red sandstone Minerva Building was constructed by local architect Frank Carruthers. From the cupola with its winged lions, the figure of Minerva, representing learning, reaches up towards the sky. As the school roll grew, an adjacent, art deco-style building was constructed in 1936 by John R. Hill, the Dumfries County Architect. The school boasts many successful alumni including J. M. Barrie of *Peter Pan* fame who attended from 1873 to 1878.

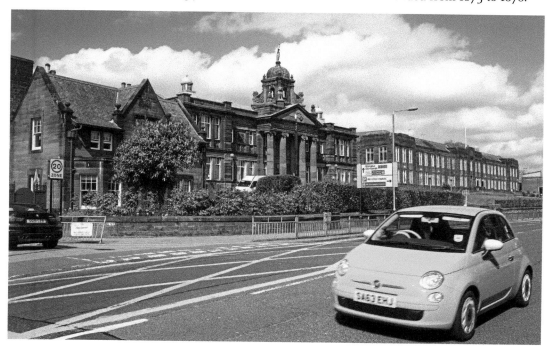

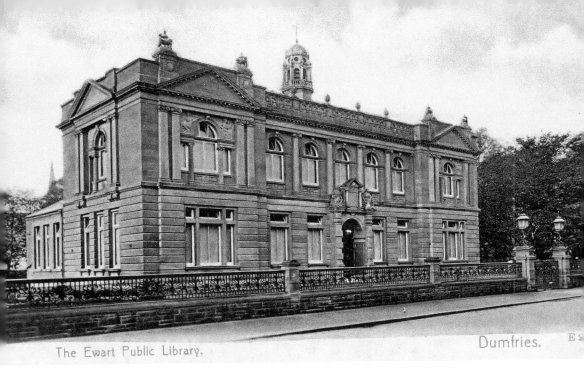

The Ewart Public Library,                                   Dumfries.

**Ewart Library, Catherine Street**

The Renaissance-style red sandstone Ewart Library was officially opened in 1904 by Miss McKie, who donated the site. Andrew Carnegie, who gave £10,000 for the building in 1898, attended and was honoured by being granted the freedom of the burgh. He had suggested the library be named after William Ewart, a former MP for Dumfries who was responsible for the Free Libraries Acts, which allowed libraries to be supported by local taxes.

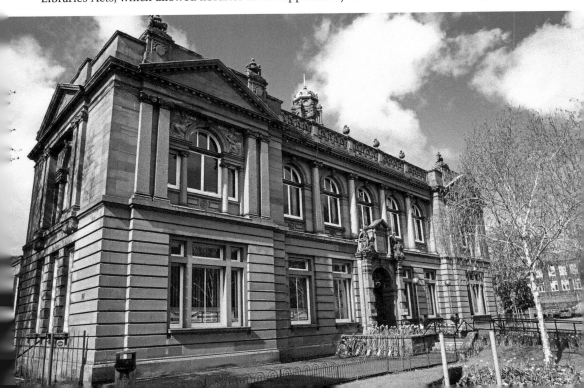

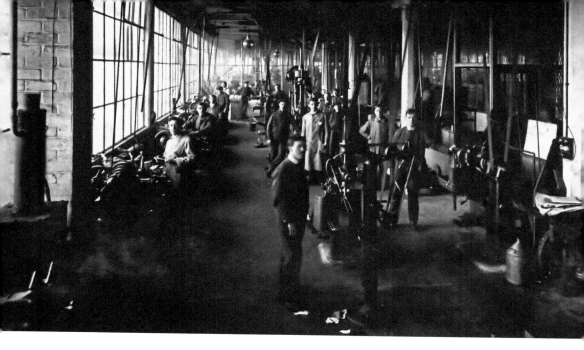

## Arrol-Johnston Motor Company, Heathhall

The car factory opened in July 1913 and was the first to be built of reinforced concrete and brick, similar in style to Henry Ford's in Detroit, designed by Albert Kahn. During the First World War it made aircraft engines then returned to car manufacturing. Its 'Victory' model did not enjoy its anticipated success, however, and sales declined in the 1920s. In 1929 it rebuilt the body of Sir Malcolm Campbell's car *Bluebird*. The company went into liquidation in 1929.

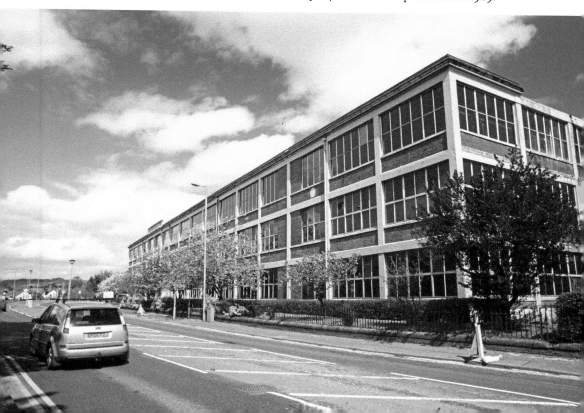

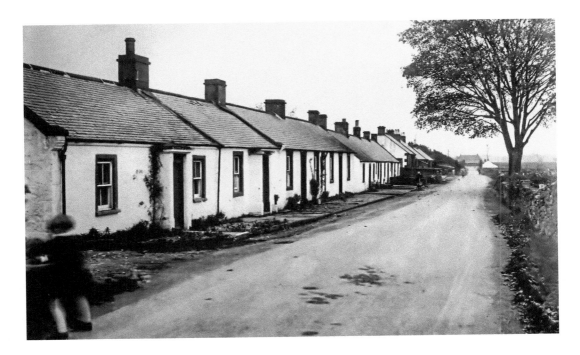

**Quarry Road, Locharbriggs**

Once a separate village, Locharbriggs is now a major suburb of Dumfries. People employed at the quarry occupied the cottages, which in this 1929 image would have enjoyed a view across fields. Locharbriggs is the oldest working quarry in the country and has been quarried since the eighteenth century for its pink and red sandstone, which has been used extensively in Dumfries, Glasgow and Edinburgh and exported abroad.

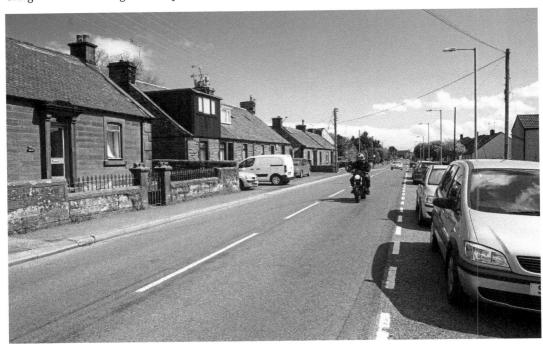

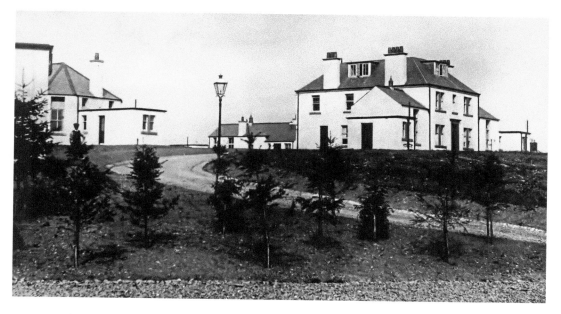

**Dumfries and Maxwelltown Combination Fever Hospital, Greenbrae Loaning**

Opened in 1910, the hospital had separate units for scarlet fever and diphtheria, outbreaks of which stemmed from overcrowding in the early twentieth century. Patients with scarlet fever stayed for forty-two days. Parents were forbidden contact with their children and could only look through a window. In the late 1940s and early 1950s poliomyelitis was also treated. Matron and staff lived in and a local GP provided medical care. It served Dumfries, Maxwelltown and Lower Nithsdale. Only the sign remains today.

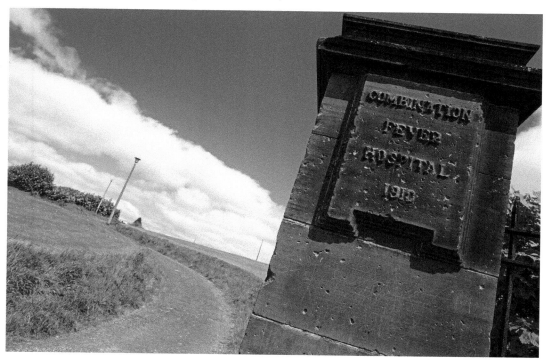

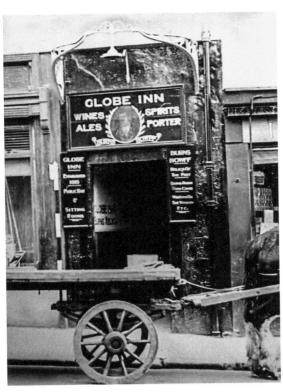

### Globe Inn, High Street

Robert Burns's favourite drinking 'Howff' was established in 1610 and has many associations with the poet. The first Burns Supper was held here in 1819 and it is home to the Burns Howff Club. Visitors can sit in his favourite chair – they must recite some poetry, though. Upstairs, in the wood-panelled bedroom he frequently used, can be seen the verses he etched on the window panes. And, of course, it is reputedly haunted, though not by the bard himself.

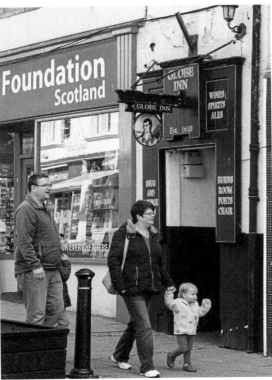

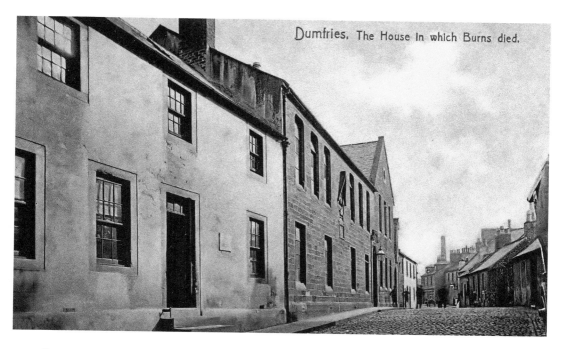

Dumfries, The House In which Burns died.

### Burns House, Burns Street

Robert Burns moved from Bank Street to this sandstone house in what was then called Mill Street in May 1793, paying £8 a year to the landlord Captain John Hamilton. Burns died, at the age of only thirty-seven, in July 1796. Many of his best-known poems were written at his desk, still to be seen in his study. His widow, Jean, opened the house as a memorial to her husband and many illustrious visitors came including the poets Samuel Taylor Coleridge, Wordsworth and Keats and American author Nathaniel Hawthorne. Burns enthusiasts from around the world visit today.

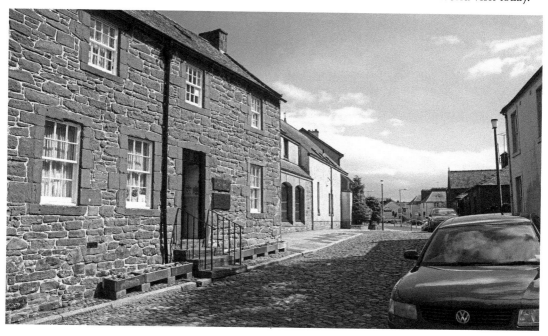

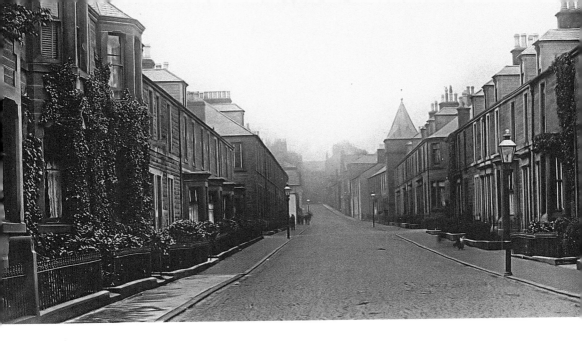

## Queen Street

A residential street of local sandstone houses. At the junction where Queen Street crosses Shakespeare Street is the gable end of the Theatre Royal, Scotland's oldest working theatre. The church on the right of the picture has gone. Never a wide street, it has been made even narrower with residents' cars parked on both sides. Soon it may look different as Sustrans are engaging on an improvement project with the community.

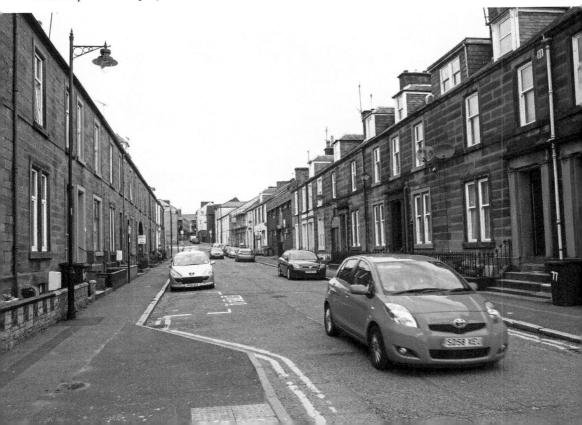

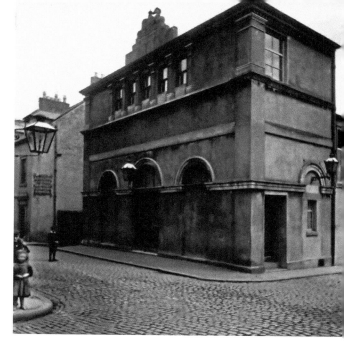

**Theatre Royal, Shakespeare Street**
Built in 1792 at a cost of £800,
it is the oldest working theatre
in Scotland. Robert Burns was a
patron. In 1902, early forms of
moving pictures began to be shown.
In the early twentieth century
it became the Electric Theatre,
continuing to show films until
competition from television led to
its closure in 1954. The Guild of
Players bought it in 1959, saving
it from demolition. It is currently
undergoing major refurbishment.

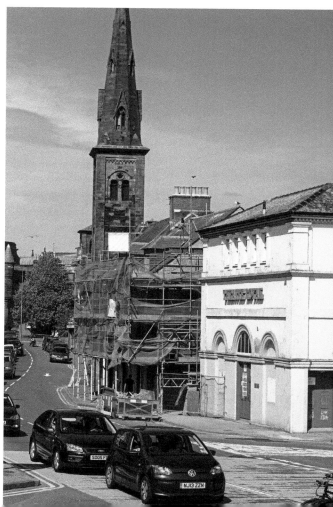

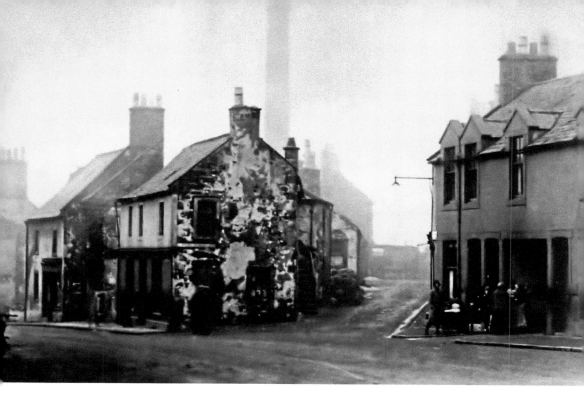

**The Penthouse End**

Pulled down in 1931, this was once a fortified house guarding the Kirk-gate, which stood at the junction of what are now known as St Michael Street and Burns Street. According to Desmond Donaldson in *Bygone Dumfries and Galloway,* one family refused to move and the gable end was demolished while they were still living in the house.

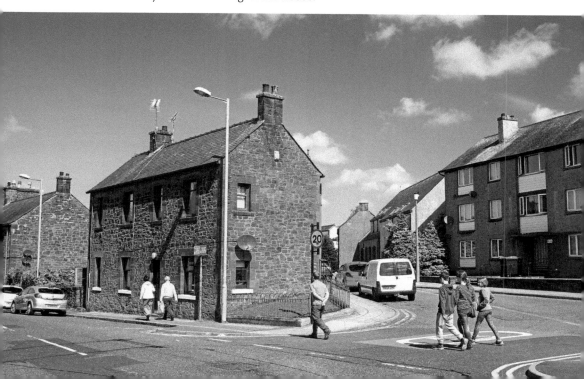

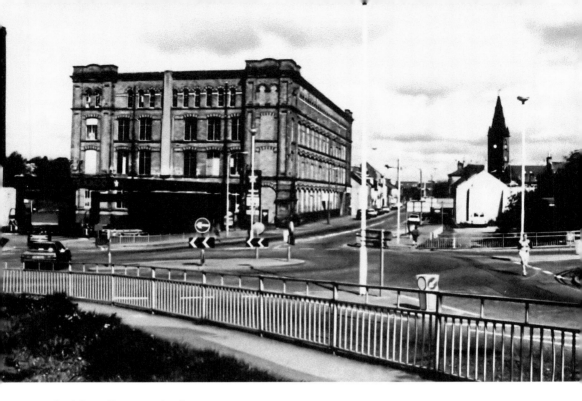

### Nithsdale Mills, St Michael Street

Robert Scott & Sons, hosiery manufacturers, established a tweed mill (the firm's second) here in 1857. In 1866, the new Troqueer Mills in Maxwelltown across the river made the firm the largest manufacturer of tweeds in Scotland, employing 1,400 workers and producing 10,000 yards of tweed each month. Wool was imported from Australia and New Zealand and the finished tweed sent all over the world. The Nithsdale Mills were replaced by blocks of flats in 1992.

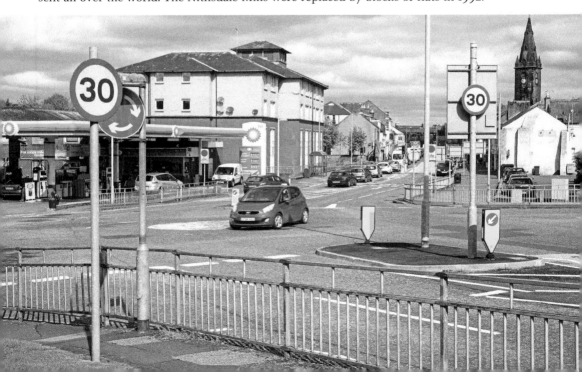

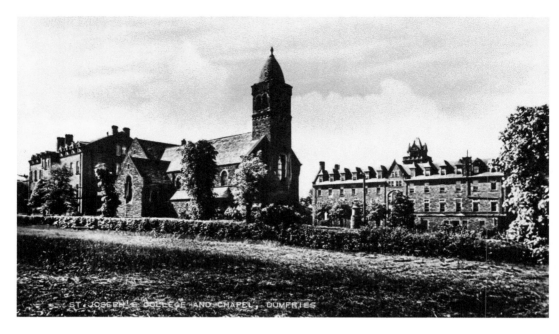

### St Joseph's College, Craigs Road

In 1873 the original Dumfries and Galloway Royal Infirmary was taken over by the Marist Brothers to establish a Roman Catholic boys' boarding school. It moved to Craigs Road in 1910. Girls were first admitted to the school in the early 1980s, by which time the school was part of the state system. Brother Walfrid, the man who founded Celtic Football Club, also helped to found the school.

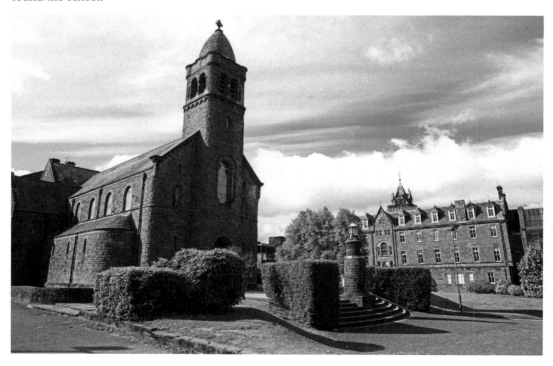

# Bibliography

Carroll, David, *Scotland in Old Photographs: Dumfries* (Stroud: Allan Sutton Publishing Ltd, 1996).

Carroll, David, *Old Dumfries* (Catrine: Stenlake Publishing Ltd, 2000).

Donaldson, Desmond, *Bygone Dumfries and Galloway*, 4 volumes (Edinburgh, M Anderson: 1976–1979).